BLUE AND YELLOW DON'T MAKE GREEN

A new approach to colour mixing for artists

MICHAEL WILCOX

Acknowledgements

The ideas behind this book have been with me for some time, but it took a team of very special people to turn them into printed pages.

I would particularly like to express my gratitude to Peter Riordan for his invaluable expertise, energy and patience. A most generous person.

The production team, Philippa Nikulinsky, Karen Grove, Danka Pradzynski and Lynn Callister deserve special mention, their professionalism and hard work made the project possible.

Thanks also to Bill and Rosemary Cranny for their constant help and encouragement. To Janet Rowe for her invaluable assistance and to Marian Kiely for working so hard on the overall plan.

I am indebted to Terry-joy, Rae and Mary of Production Plus for their efforts in organising production and for their generous advice.

I also wish to thank Paul Green-Armytage and Ron Price for their kind help and advice.

Finally, I must thank my wife Dawn for her enduring patience, hard work and support.

Editor Peter Riordan

Designer Danka Pradzynski

Illustrators Philippa Nikulinsky Michael Wilcox

Finished Artist Karen Grove

Jacket design and Illustration by Nigel Wright and Beverley Speight

First published in the UK in 1989 by William Collins Sons & Co. Ltd

Reprinted in 1990

First published in 1987 by Artways P.O. Box 350 Cloverdale Perth Western Australia Printed in Singapore through Imago Productions (F.E.) Pte. Ltd.

Text, Illustrations and Arrangement Copyright © Artways 1987

Colour Bias Wheel © Michael Wilcox

All rights reserved. No part of this publication may be reproduced, stored in a retrieval system, or transmitted, in any form or by any means, electronic, mechanical, photocopying, recording or otherwise, without the prior written permission of the publishers.

British Library Cataloguing in Publication Data Wilcox, Michael. 1942-Blue and yellow don't make green. 1. Paintings. Colour. Manuals 1. Title 752

ISBN 0 00 412455 3

Introduction

Colour has long aroused strong emotions in man. It has a powerful and direct influence on the brain giving rise to responses varying from aggression to tranquillity. There is every reason for anyone using colour to understand and take control of this very forceful means of communication.

Artists, whether amateur or professional, would invariably agree that the selection and use of colour is of paramount importance to their work. And yet despite growing interest in colour's potential, a great deal of misunderstanding surrounds colour mixing.

As children we are told that there are three colours — the primaries — which can be mixed to make all other colours. The teacher provides a red, a yellow and a blue and we quickly find that we can mix them and obtain further colours.

Those of us who become further involved in art find this approach too limiting, we desire a wider range of colours to cater for our more sophisticated requirements.

Yet it seems that however many colours we purchase and whatever we read on the subject, at the end of the day it still remains very much a hit

or miss affair.

The need to be able to mix any desired result quickly, accurately and without waste is readily apparent but unfortunately very few are able to do this. Even after many years of experience most artists find difficulty mixing colours.

Are there reasons for these difficulties? Can they be overcome?

I believe that the three primary system on which we rely so heavily has in fact created many of the stumbling blocks to mastering colour mixing. It is a very rough, crude guide which offers help with one hand and takes it away with the other.

The problems associated with colour mixing can be overcome but first we need to discard the notion of primary colours and replace it with a more up-to-date conceptual framework.

Michael Wax

Michael Wilcox.

Contents

1	The Current Approach to Colour Mixing	7	5	The Painters' Primary Colours Do Not Exist	37
1.1	The Three Primary System	7	5.1	Pigment Colour Bias	37
1.2	History and Development of	12	5.2	The Colour Bias Wheel	39
1.3	the Three Primary System Colour Memory	12 14	5.3	The Surviving Light	40
			5.4	The Traditional View	42
2.	The Colour Bias Wheel	15	5.5	The Six Principle Colours	44
2.1	Colour Bias	15	6	Exploring the Basic	45
2.2	The Bias Wheel in Action	16		Palette's Range	
3	The Basic Palette	21	6.1	Selecting Contributing Colours	45
			6.2	Exploring the Clear Colours	52
3.1	The Limited Palette	21	6.3	Colour Wheel A —	- /
3.2	Cadmium Red	22		Clear Colours	54
3.3	Alizarin Crimson	22	6.4	Neutralized Colours	55
3.4	French Ultramarine	22	6.5	Colour Wheel B	61
3.5	Cerulean Blue	23	6.6	Colour Wheel C	62
3.6	Lemon Yellow	23	6.7	Colour Wheel D	63
3.7	Cadmium Yellow Pale	23	6.8	Reds, Yellows and Blues	64
			6.9	The Exercises	65
4.	Colour Biases	25			
			7	Greys and Neutral	(-
4.1	What is Colour?	25		Colours	67
4.2	Primary Colours	30	7 1	Greys and Neutrals from the Complementaries	
4.3	Inside the Paint Film	30	0 7.1		67
4.4	Mixing the Three "Primaries"	32	7.2	Yellow/Violet	69
4.5	Mixing Just Two "Primaries"	34	7.3	Blue/Orange	70

/.4	Red/Green	/ 1	11.2	mixing standard Colours	99	
7.5	Other Complementary Pairs	72	10	Marie to a Wantana Marie	101	
7.6	Colour Wheel E	73 12 N	Mixing Various Media	101		
7.7	Colour Wheel F	74	12.1	Pastels	101	
8	Transparent, Semi-		12.2	Coloured Pencils	104	
Ü	Transparent and Opaque Paints		12.3	Silk Screen Inks	106	
		75	12.4	Watercolour	108	
8.1	Paint Films	75	12.5	Gouache	109	
8.2	Transparent Colours	77	12.6	Oil Paints	110	
8.3	Colour Wheel G	84	12.7	Acrylics	112	
8.4	Further Transparent Colours	85	12.8	Placing Further Colours	114	
8.5	Opaque Colours	86	12.9	Subtractive Mixing in Practice	116	
8.6	Colour Wheel H	86				
8.7	Further Opaque Colours	87	Appendix			
			A	Light Absorption	118	
9	Adding White and Black	89	В	Subtractive Mixing?	119	
9.1	Adding White	89	С	Spectral Curves	120	
9.2	Adding Black	92				
10	Browns	95				
10.1	How to Make your own Browns	95				
10.2	Manufactured Browns	96				
11	The Palette	97				
11.1	Summary of the Extended Palette	97				

The Current Approach to Colour Mixing

We must understand the inherent limitations of present methods if we are to expand our capabilities.

- 1.1 The Three Primary System
- 1.2 History and Development of the Three Primary System
- 1.3 Colour Memory

1.1 The Three Primary System

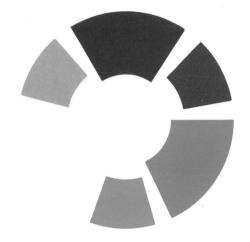

Traditionally the 'primaries' are thought of as being the base colours from which other colours are mixed but which cannot, themselves, be created from other colours.

Red, yellow and blue are the 'primaries' used in the mixing of paint, inks, pastels, coloured pencils etc. They can be found on a great variety of colour wheels, together with the resulting 'secondary' colours: blue and yellow are shown as making green, yellow and red are shown as making orange and red and blue making violet.

On paper the system appears to work very well. All that needs to be done is to select a red, yellow and blue from the range offered and mix away.

Put to the test the three

primary system seems sound enough. A green does result when blue and yellow are mixed and violet and orange can be obtained by combining other 'primary' colours. The first of the problems involved with the 'three primary system' comes with the selection of the colours. Which red, yellow and blue to use? There are so many to choose from.

With so much conflicting advice being offered by books, fellow artists and teachers, painters often turn up at their art material supplier with little idea of where to start.

Typically they begin by purchasing a variety of reds, yellows and blues.

Three or four tubes of each 'primary' colour is generally considered an adequate start.

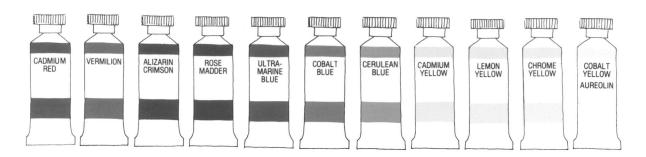

And a few other colours too, just to be sure.

A common approach is to start by squeezing small paints are use from the tube amounts of each of the colours on to the palette. Many of the

paints are used as they come from the tube, with little or no modification.

Work on the painting progresses, but there soon comes a time when a particular colour is required that is not available ready mixed. Let's say a bluish violet is wanted.

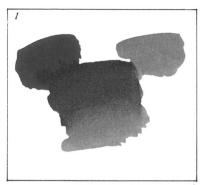

A red and blue are mixed, but the result is nowhere near the one needed.

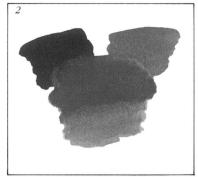

A different red is tried. Things get worse — the mix has turned grey.

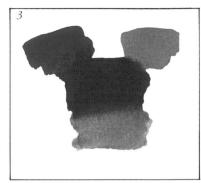

Perhaps it needs another of the many reds on the palette. No, that's worse still.

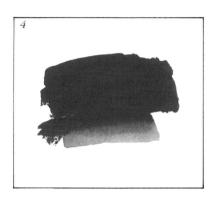

There is now a large amount of dirty grey paint — mud — on the palette. Can't discard it because paints are so expensive nowadays.

Some of the mix is scraped up and moved to a clean part of the palette.

Maybe it was the blue that was at fault.

The original red is reintroduced and another blue mixed in.

It's a little bit better, but still very dull.

More of the red and blue is added to the growing mix and it starts to look more like violet.

A little yellow paint is accidently mixed in. Not to worry, it's only a tiny amount.

Suddenly the mix is worse than ever. It's become a very dark grey.

Understandable frustration sets in. The two large blobs of unwanted (and expensive) grey paint are scraped off and a fresh start is made.

The colour that is eventually used is not quite the one that was in mind but it will 'have to do'.

If this is all very familiar to you, take heart because many artists can sympathise with your predicament. They too end up using colours that are less than satisfactory, thereby severely limiting their colour expression, exhausting their patience and attaining a diminished level of satisfaction from their work.

Thanks to our present wasteful colour mixing practices, the only ones to benefit are the paint manufacturers.

Confusion arises out of the vast choice of 'secondary' colours available from the 'primaries'.

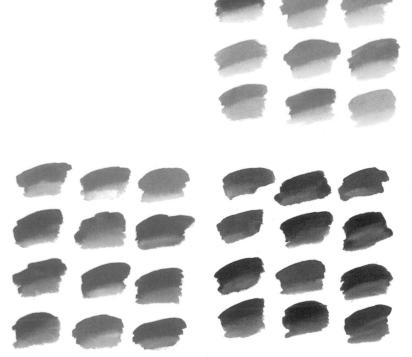

Such a wide range of greens, oranges and violets is produced that forecasting the final colour is no easy matter.
They are all useful colours but how can we be sure of mixing them to order?

One way around the problem that is often suggested is to select just one yellow, one red and one blue and to mix all the 'secondary' colours from just these three:

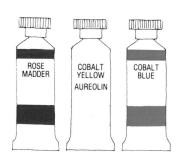

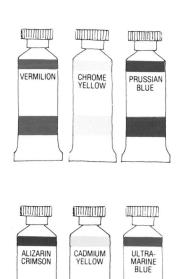

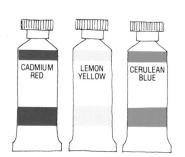

This combination gives clear violets but dull greens and oranges.

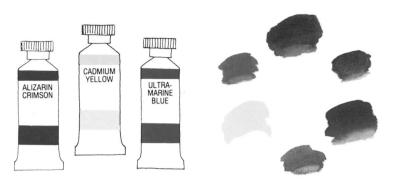

Here the greens are bright, but the oranges are dull and the 'violets' more like dull browns.

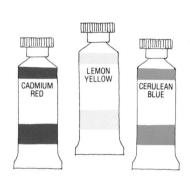

Clear oranges but very dull 'violets' and poor greens.

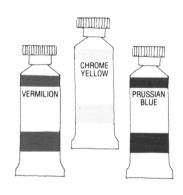

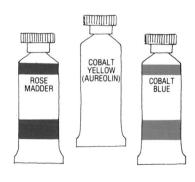

These three produce better all round results, but the oranges are still dull, the violets not especially bright and all three, being transparent, look rather washed out. These colours also happen to be very costly.

Try as we might, it is impossible to find three 'primary' colours that will give us a series of clear'secondaries'

1.2 History and Development of the Three Primary System

From the very earliest times, confusion has gone hand in hand with attempts to understand colour.

A multitude of interpretations have been offered about the origins and relationships of colours, but little attention has been paid to colour mixing until comparatively recently.

Surprisingly, it was not until about 1731 that the German theorist Le Blon made a discovery that many now would say should have been obvious: that a comprehensive range of colours could be obtained by using just three basic colours, red, yellow and blue.

Le Blon's discovery met with wide acclaim, one writer of the time stating "that invention has been well approv'd thro'out Europe, th'o at first it was thought impossible".

His findings were quickly

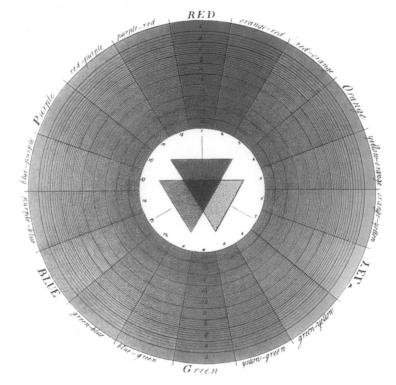

embraced, particularly by the printing trade, but it was not until some forty five years later that his work was presented in a practical form.

In 1776 Moses Harris

published the first organised colour wheel in an attempt to replace the then current understanding of colour, which he described as being "so dark and occult".

28 TRACT OF COLOURING.

PAINTING can represent all visible Objects, with three Colours, Yellow, Red, and Blue; fort all other Colours can be compos'd of these Three, which I call Primitive; for Example.

Yellow
and Red make an Orange Colour,
Red and make a Purple and Violet Blue Colour.

Blue make a Green Colour,

And a Mixture of those Three Original Colours makes a Black, and all other Colours whatsoever; as I have demonstrated by my Invention of Printing Pictures and Figures with their natural Colours.

Yellow

The first printed description on the nature of the 'primaries'.

He declared that red, yellow and blue — the "primitive" (primary) colours gave rise, through mixing, to the "prismatic" (secondary)

colours, orange, green and violet.
And so it has remained ever since.

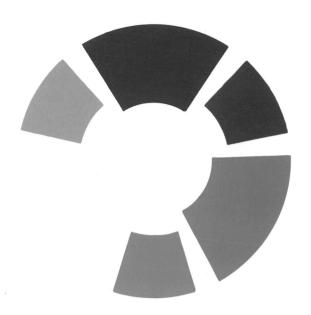

The use of the three primary system has gained universal approval and now forms the basis on which colour mixing is taught throughout the world.

The heavy reliance on this

system cannot be claimed, however, to have led to generations of skilled colour mixers

On the contrary, it has led to muddled, confused frustration.

No-one denies that the three primary system has always been clumsy to use. The difficulties are usually explained away in the following manner:

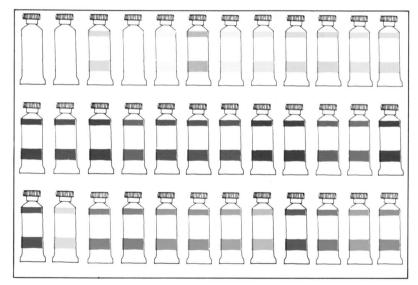

Or alternatively;

'I realise that it is not possible to obtain pure primaries in pigment form; the red is always a bit orange or violet for example, but one day such colours will probably become available and then it will be very easy to mix almost every colour imaginable'.

In both cases the belief in the three primary system is firmly entrenched.

1.3 Colour Memory

A cornerstone of the three primary system is its reliance on colour memory. Many art instruction books contain colour samples together with information on the various reds, yellows and blues that were mixed to achieve them. The reader is expected to absorb such information.

Typical advice runs along

the lines: 'Mix red A with yellow B and store the result, orange C, in your memory for future use'.

Although individuals vary in their ability to recall colours accurately, we are, on the whole, equipped with a relatively poor colour memory. If you have ever tried matching up a piece of material or paint sample in a shop with the colour of your curtains or living room wall you will realise the difficulties from first-hand experience.

This is a rather extreme example, though not an uncommon one. It is almost as difficult to match up colours from memory when they are directly in front of us.

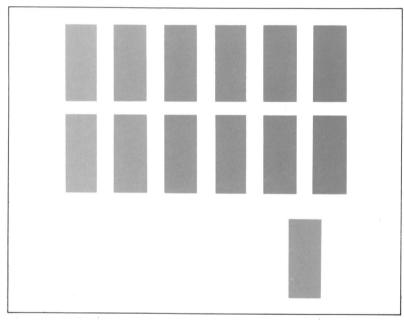

Take a dozen pieces of paper of the same hue, all slightly different greens say.

If you have another sample that matches up with one of them, you will in all probability have to resort to butting the pieces together to obtain a match unless the differences are glaringly obvious.

In the split second that it takes to look from the sample to one of the twelve choices, the image of the first colour will fade considerably. It is only when the two pieces are put side by side that we can circumvent our reliance on colour memory.

The simple fact is that we quickly forget all but the most general features of a colour as soon as we look away from it, and yet, the very foundation of colour mixing instruction

relies on remembering the results of countless colour mixes.

Our colour memory certainly helps us achieve very general results but it is quickly overwhelmed attempting a fuller repertoire.

This approach, then, is unwieldy and unworkable and even years of experience mixing colours does not reverse that fact because we must still rely on an unreliable colour memory.

The Colour Bias Wheel

The leanings or biases of "primary" colours determine the type of colour we finally mix. To recognise and understand them is to manipulate colour with total control.

2.1 Colour Bias

2.2 The Bias Wheel in Action

2.1 Colour Bias

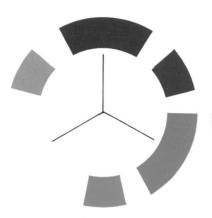

The traditional 'three primary wheel' is of limited value as it suggests the existence of colours that simply are not available, ie, one red, one yellow and one blue which together will give good, clear, predictable 'secondary colours'.

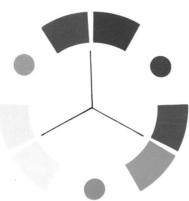

Let's stay with the basic format but use two 'types' of red, an 'orange' red and a 'violet' red; two blues, a 'violet' blue and a 'greenish' blue, and two yellows, one an 'orange' yellow and the other a 'slightly greenish' yellow.

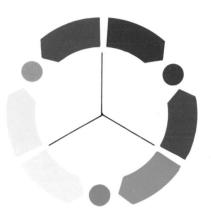

The diagram can be further modified by forming the colours into arrows, arrows that point either towards or away from the 'secondaries'.

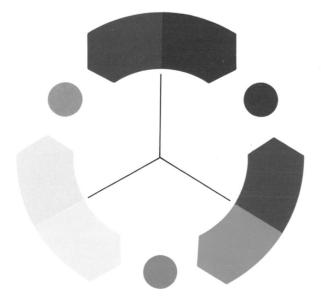

The final diagram, which we will call the COLOUR BIAS WHEEL, shows the six colour 'types' that will be used throughout this book to replace the traditional three colours.

They are an orange-red, a violet-red, a violet-blue and a green-blue, a green-yellow and an orange-yellow. These six are the MINIMUM number of colours needed for a wide selection. Each of the colour types leans or is biased towards a 'secondary' colour, as shown by the arrows.

2.2 The Bias Wheel in Action

Violets

Let's put the colour bias wheel to the test by using various colour combinations to mix different violets.

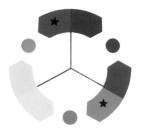

The orange-red and the green-blue both point AWAY from the violet position, indicating that they are unsuitable for mixing clear violets.

As the bias wheel forecast these two colours do not produce a clear violet. The mix is more like a grey-brown.

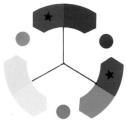

This time we will stay with the same red but use a type of blue that the wheel tells us is a good choice, as it points TOWARDS the violet position.

A better result although it is not a particularly pure violet.

The bias wheel did tell us however to expect a violet that is neither dull nor bright. The red pointed AWAY from the violet and the blue pointed TOWARDS it.

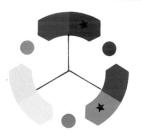

Let's ask the wheel for another type of dull violet. This time using the red that it

suggests but a blue that points AWAY.

Another in-between violet — neither dull nor clear. Just as predicted.

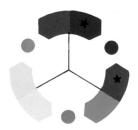

Now we will take the bias wheel's advice and use the colours suggested.

Both arrows, the violet-red and the violet-blue point TOWARDS the violet position.

As forecast, the resulting mix is a good clear violet.

Greens

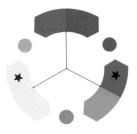

The bias wheel worked with violet so let's see if it works with green. Orange-yellow and violet-blue both point AWAY from the green.

As the wheel forecast, the resulting green is very dull.

A mixture of orange-yellow and violet-blue cannot be expected to give a pure green. Both point AWAY from the green.

We should get a better result, according to the bias wheel, if at least one of the arrows points towards the green position.

A purer green but still not very bright.

The wheel indicated the likely result of using these two types of colour.

Let's go the other way round and select a suitable yellow but an 'unsuitable' blue.

A different mid-green emerges, neither very dull nor very clear. All of the greens mixed so far are equally

useful, but now at least we can predict them. No longer is it a hit or miss affair.

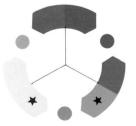

The bias wheel indicates that a green-yellow and a green-blue are the ideal colours to use for a pure green.

A much brighter green emerges from this mix.

Both the yellow and the blue point TOWARDS the green, indicating that they are the best choice for a pure result.

Oranges

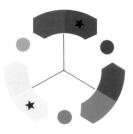

The bias wheel helps in mixing a range of oranges too.

A violet-red and a greenyellow give a very subdued orange.

Both the red and the yellow point AWAY from the orange position.

If a slightly dull orange is required it is a simple matter to choose one possible pair of contributing colours.

A useful and very predictable mid-orange emerges —

as the bias wheel indicates.

Another way to produce a dulled orange is to use the suggested red but the 'wrong' yellow.

As expected, a dulled or neutral orange results. Note the difference between this and the last mix.

The wheel forecast the result, taking the guessing out of colour mixing.

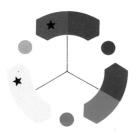

For the purest mixed orange the choice is an obvious one.

The result is clean and clear.

Both colours point TOWARDS the orange position.

SUMMARY

Reliance on the use of just three 'primary' colours has led to unnecessary confusion.

By suggesting, as it does, that a single yellow, red and blue will give useful results, it has led many a painter on a wild goose chase trying to identify the ideal 'primaries' to

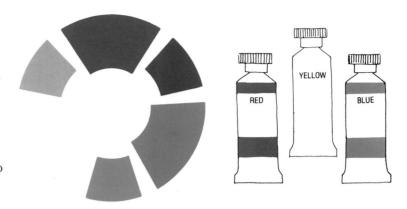

As an alternative, attempts have been made to formalise colour mixing by giving examples of various results for the user to memorise.

As this approach relies on our very shaky colour memory, it has been of limited use.

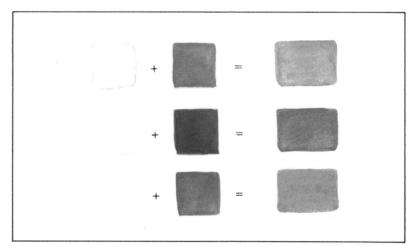

If the three 'primaries' (a presumably pure red, yellow and blue) are converted into six colour 'types' and placed into position on a wheel which indicated their leanings or biases, the results of colour mixing can be forecast and contributing colours chosen with care.

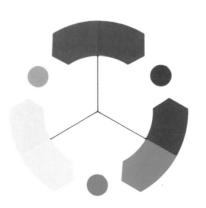

find that the colour bias wheel will also help in darkening colours and in creating greys.

Before moving on, let's select a basic palette with which to work. Although the colour names are common for watercolours, oils and acrylics, they are not always used by

manufacturers of other media.

Later in the book we will

The colour types however will remain constant.

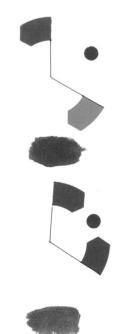

The Basic Palette

The palette suggested here represents the six colour types: orange-red, violet-red, violet-blue, green-blue, green-yellow and orange-yellow.

- 3.1 The Limited Palette
- 3.2 Cadmium Red
- 3.3 Alizarin Crimson
- 3.4 French Ultramarine
- 3.5 Cerulean Blue
- 3.6 Lemon Yellow
- 3.7 Cadmium Yellow Pale

3.1 The Limited Palette

It is not an easy matter to gain complete control of a palette consisting of even three colours, yet many start their painting career by assembling as many colours as they can. The average painter's box looks as if it would benefit from the addition of a set of wheels and an engine. This approach can only lead to confusion, and expensive confusion at that.

Rather than go all out to make the paint manufacturer happy, it is preferable to concentrate on gaining control of a more limited palette — limited in the number of contributing colours rather than the possible results.

Most of the great masters achieved the most incredible effects from very limited palettes. Their colour effects can be reproduced today by the painter with an understanding of colour mixing and use.

Built-in Confusion

The bewildering range of colours available on today's market undoubtedly causes a great deal of confusion. This situation is exacerbated by many manufacturers of artist's paints who market their products under an everwidening list of often meaningless names.

Many painters 'feel safe' only if they have purchased as many different colours as possible. They work from

boxes cluttered with a lot of quite unnecessary tubes of paint. This arrangement not only adds enormously to the cost of painting — high enough as it is — but also lulls the painter into a false sense of security. Assuming that a large range will obviate the need for much mixing, colours are used straight from the tube with little modification. The result of such an approach is work of a limited scope, often containing harsh, poorly balanced colours and is easily recognised by the trained eye as a 'tube painting'.

A good number of these paints are not 'unique' colours at all, but simple mixes that we could produce ourselves using paint of a higher quality than is usually employed in manufacturers' colours.

By using the basic palette suggested here, you will be able to mix a very extensive range of colours and have a greater control over your materials.

There are, of course, an almost unlimited number of 'basic palettes' that can be put together, but this particular selection will, I believe, give you the greatest possible range.

This palette provides the basis for a controlled approach to colour mixing. Its use depends entirely on knowing which 'type' of colour each of the six represents. Once you appreciate the significance of the 'colour types' you can apply this knowledge to any other colour you possess, whatever your medium or discipline, whether it be, for example, painting, printing, pottery, using coloured pencils or inks. The principles remain the same.

3.2 Cadmium Red

Pigment Red 108

A warm red, leaning towards orange.

A strong, pure, intense orange-red, opaque and durable. It possesses a fairly high tinting strength with good covering power.

Beware of cheaper, student grades labelled as Cadmium Red or Cadmium Red Hue. They usually contain inferior substitute ingredients and have an unattractive appearance. It

is worth spending the extra money for the artist quality, which is always brighter and more reliable than imitations.

The correct ingredients to look out for are 'Cadmium Seleno Sulphide'. You will find that the colour tends to vary between manufacturers so choose carefully. The brighter the better.

Stable and light resistant under normal conditions, it has earned a well deserved place on many artists' palettes. Cadmium Red is gradually replacing genuine Vermilion, an inferior and expensive material prone to darkening.

3.3 Alizarin Crimson

Pigment Red 83

A cool red, leaning towards violet.

Just as Cadmium Red has largely surplanted Vermilion on the modern artist's palette, so too Alizarin Crimson has become an ideal replacement for the Madder reds, Magentas and Carmines which are often prone to fading. Produced in a range of rich, dark, cool reds, it yields soft delicate pinks when mixed with white or diluted.

A particularly clear and transparent colour, Alizarin is ideal for glazing. If laid on too thickly in a painting, either alone or in mixes, this beautiful, luxuriant colour loses its deep glow and tends to dominate surrounding hues.

It is always preferable to use the artist quality. Avoid

the cheaper grades as they often contain an excess of filler, or are otherwise inferior.

Alizarin Crimson has an unfortunate tendency to fade when applied thinly or mixed with white. Heavier applications are more resistant to light.

Despite this restriction, I have suggested Alizarin since it can be found in most paint boxes and is a good starting point. As a more reliable alternative (particularly with acrylics where Alizarin Crimson is not always available) look for either a Napthol Red or a Quinacridone Red with a similar violet undercolour.

3.4 French Ultramarine

Pigment Blue 29

A warmish blue, biased towards violet.

Pure and durable with a high tinting strength. It needs to be used carefully, either alone or in mixes, due to its strength.

Unlike other blues which invariably have greenish undertones, Ultramarine leans towards violet. This makes it a vital tool in colour mixing.

The original Ultramarine, produced from the very expensive natural material

Lapis Lazuli, was replaced after 1828 when the French Government awarded a prize to the inventor of a synthetic version which became known as French Ultramarine.

The creation of an artificial Ultramarine was a major breakthrough in the history of artist's pigments. It is an important blue, considered a necessity by many artists.

3.5 Cerulean Blue

Pigment Blue 35

A cool blue, leaning towards green.

A bright, clean, strong light blue which is often used for depicting clear sunny skies. Cerulean has a greater opacity than most other blues, which gives it good hiding power. Although dark blues will cover well, they rely on their depth of colour rather than their 'body'

A very difficult pigment to produce, genuine Cerulean tends to be expensive. There are many substitutes available but none match the true pigment for purity and colour.

Choose carefully, the better qualities are usually excellent value for money. Once again

There are many imitations on the market.

avoid, if possible, the cheaper grades, as they are usually only a mixture of Phthalocyanine Blue and other blues. Extremely permanent, Cerulean possesses a very high degree of fastness to light.

3.6 Lemon Yellow

Pigment Yellow 3 Arylide Yellow

A cool yellow, leaning towards green.

Many of the Lemon Yellows available have the unfortunate tendency of gradually turning green, especially if they are ground in oil. For this reason you should particularly avoid Chrome Lemon and Strontium Lemon. I find the most reliable products, in order of preference, are based on Arylide, Cadmium and Barium. A well produced Lemon made from Arylide is usually the safest. It also tends to be very clean and fairly transparent.

Transparent and delicate, a well made Lemon Yellow is a pale durable colour that retains its brightness very well.

The name is a general term used for a light, greenish yellow and is often used indiscriminately to describe such a yellow.

When purchasing this colour, it is vital that you check the ingredients used in its manufacture.

Certain Lemon Yellows will turn green.

3.7 Cadmium Yellow Pale

Pigment Yellow 35

A warm yellow, leaning towards orange.

When made well, this paint is lightfast and permanent for all mediums.

It is an intense, brilliant, pale yellow that is biased towards orange. Between this colour and the cooler Lemon Yellow lies the basic imaginary PURE yellow. Although rather expensive owing to the pigment used, its brightness and permanence make it well worth the money.

Substitutes bearing the name in their titles, such as Cadmium Yellow Pale Hue, are invariably inferior substitutes. Check that the ingredients are based on Sulphide of Cadmium.

If you do not possess Cadmium Yellow Pale or Light then the medium version, usually just called 'Cadmium Yellow' can be used. The colour bias remains the same although the results are rather stronger.

Notes on the Suggested Palette

Artist pigments vary considerably in colour intensity and consistency. While the colours I have suggested for a basic palette are of varying strength, I have avoided the very strong staining colours.

Transparency also varies. Alizarin Crimson is exceedingly transparent, as is French Ultramarine.

Cadmium Yellow Pale is reasonably opaque, although its strength does allow it to be applied in thin layers. Quite weak in tinting strength, Lemon Yellow can be thinned to give transparent coats, (particularly if it is based on Arylide). Cadmium Red and Cerulean Blue are both fairly opaque. The selected colours therefore vary in transparency.

My choice of paints, like any other palette, is open to criticism. However it does give a very wide range of colours and degrees of transparency.

You will now have the necessary information to be able to change any of the suggested colours for others you might prefer.

Trial mixes will indicate the bias of any alternatives you choose. If, for example, you wish to place a particular red on the colour bias wheel, first mix it with Ultramarine Blue. A dull result will indicate that the red is orange in nature, a violet result that the red is similar in character to Alizarin Crimson and should be used accordingly.

There are alternatives to the colours that I have suggested that come closer to pure 'primary' colours. Typical of these are:

Rose Madder Genuine

It is slightly closer to true red than Alizarin Crimson and is also very transparent. Its weakness and high cost put me off using it to any great extent.

Aureolin

Aureolin, applied very thinly, is a relatively clear, almost unbiased yellow. Again it is very weak in mixes. Applied heavily, Aureolin takes on a very unattractive, leathery appearance.

Cobalt Blue

Cobalt Blue is almost a pure blue, without a strong leaning in either direction.

While I prefer the greens that come from Cerulean mixes, you might decide to use Cobalt Blue instead. It is certainly a very transparent blue and for this reason will be introduced later.

Colour Index Names

The Colour Index Name is an important means of identifying the pigment in a paint, and it should be printed somewhere on the labelling.

Colour Index Names are a type of international shorthand for precisely identifying colourants in a way that is not possible with Common or Trade names.

The name is often abbreviated; PIGMENT YELLOW 3 for example might be described as PY3.

4

Colour Biases

Understanding colour bias and the processes at work within the paint film transforms colour mixing into a controlled thinking process.

- 4.1 What is Colour?
- 4.2 Primary Colours
- 4.3 Inside the Paint Film
- 4.4 Mixing the Three "Primaries"
- 4.5 Mixing Just Two "Primaries"

4.1 What is Colour?

Where is the apple's "redness"?

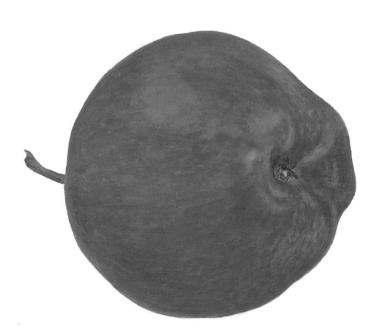

Is it in the skin of the apple?

In the light coming through the window?

In the eye of the viewer, or in the brain?

Light

The sun emits a variety of wave-like radiations, each of which can be thought of as similar to a rope being shaken at one end.

Many of these radiations, known as electromagnetic waves, are prevented by the atmosphere from reaching the earth. X-rays, infra-red rays and light rays are among those electromagnetic waves which do penetrate the atmosphere.

The visible light that reaches the earth is made up of wavelengths that, although similar in character, vibrate at slightly different speeds or frequencies. Varying light wavelengths represent different colours and together they reach us in the form of white light.

For the sake of clarity the waves are shown in colour. While they remain part of the light, they cannot be seen.

This white light is the natural light we call daylight. Since the various colour wavelengths that constitute daylight are travelling in a combined form, they must be broken down, or decoded, if they are not to remain simply as white light.

The Prism

One way of separating the individual colours is to pass the light through a prism.

When light strikes an angled surface it is deflected slightly from its path. In the case of a glass prism, the light bends but continues its journey. Each of the various wavelengths that make up white light are bent at slightly different angles.

Because the wavelengths are bent by differing amounts as they pass through the prism, they become separated from their travelling companions. If a white card is put in their path, the full colours of the spectrum are revealed.

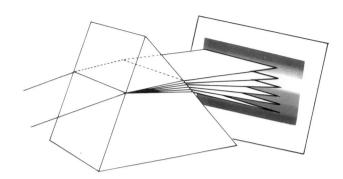

Through his work with the prism, Newton was able to prove that all colours are

physically contained within white light.

Surface Colour

The colours contained in natural or artificial light can be made visible if the light strikes a surface.

But why do surfaces reveal different colours when they are struck by the same white light? The answer is due to the nature of matter and the fact that, like X-rays and infra-red radiation, light is a form of energy.

The make-up of matter:

Every object is made up of atoms which are seething with invisible energy. Electrons are in constant orbit around their centres or nuclei.

A black surface will absorb the energy of the light

The energy contained in white light is often compatible with the energy within a surface and when that happens, they merge. The energy within the surface absorbs the energy within the light.

Exactly what happens when light strikes a surface depends on the molecular make-up of that surface.

Some surfaces efficiently absorb all the different 'colour waves', reflecting very little back. Such surfaces appear black. The energy contained in the light which a black surface absorbs is turned into heat.

A white surface on the other hand, has a molecular make-up that rejects or reflects almost all 'colour waves' equally. The 'colour waves' therefore remain as white light.

A yellow surface absorbs nearly all 'colour waves' except the yellow which is rejected and reflected back from the surface to our eyes. As we can now only see the reflected yellow portion of the light, the object appears to be yellow. The other 'colour waves' have been absorbed and turned into heat.

Since all the 'colour waves' contained in the white light arrived at the surface at the same time, the 'yellow waves' are reflected over the entire surface area.

If a surface appears blue, it follows that the other 'colour waves' — the red, orange, yellow, green and violet — have been absorbed into the surface and the 'blue waves' reflected back to the eye.

When we describe a flower as being red, what we are really describing is that part of the light left after the rest has been subtracted. The molecular make-up of its

surface is such that it absorbs every light ray except the red. The flower ITSELF does not somehow possess the red. The colour is generated ONLY by the light falling on it.

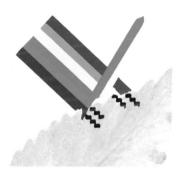

It is not only single colours that are reflected: a yellowgreen leaf reflects varying proportions of both yellow and green.

The colour that the viewer eventually receives, therefore, is the remnant or residue of the light that arrived at the surface. The rest has been absorbed.

The hues of the spectrum are reflected in various combinations to produce the immense range of colours we see about us.

Colour Sensation

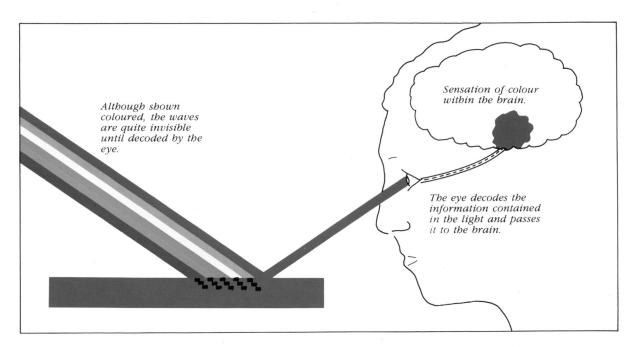

We should think of the various 'colour waves' as carriers of information. Information the eye can

process into a form which is suitable for the brain to make use of.

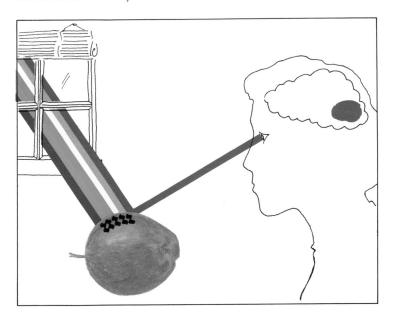

To return to the question of the apple's colour, we can now say that the redness was carried through the window in the light, that it was reflected from the skin of the apple (after losing its travelling companions), that it travelled as a code to the eye and was then passed to the brain, where it was turned into a sensation of redness.

If the apple is now covered over, it is no longer red. Without light its true colour is black. It can only appear red when the red 'colour waves' contained in the light are present.

4.2 Primary Colours

There are other sets of primary colours we should know about in addition to the traditional artist's primaries of red, yellow and blue.

Additive Primaries

The primaries of light, orange-red, green and violetblue, combine to form white light when they are all at the correct relative luminance.

They are known as ADDITÍVE primaries because when they are mixed, light is ADDED. Red and green for example make yellow, which is lighter than either the red or the green.

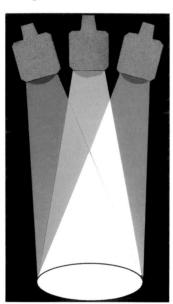

Subtractive Primaries

Red, yellow and blue, are the subtractive primaries traditionally used in paint mixing.

They are known as SUBTRACTIVE primaries due to the fact that colours that are mixed from them become darker, blue and yellow for example producing green which is darker than at least the yellow. Light is SUBTRACTED when they are combined.

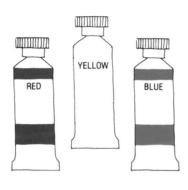

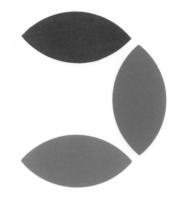

Psychological Primaries

First proposed by Leonardo da Vinci, the psychological or perceptual primaries are those colours that do not appear to involve any other colour. The colours red, yellow, blue and green all appear to be quite unlike each other. We cannot see, for example, any red in yellow or any blue in red.

4.3 Inside the Paint Film

In order to understand subtractive mixing and how it can best be employed by the painter, we need to study the processes actually taking place within the paint film.

Our poor colour memory does not allow us to learn very much from the surface appearance of colours.

Consider the events which take place when light strikes a surface: a surface painted, for example, with red oil paint has absorbs all 'colour' lightwaves a molecular make-up which

and turns them into energy,

with the exception of the 'red' lightwaves which are rejected.

Pigments, the colouring matter of paints, are tiny particles which reflect certain colours very efficiently.

A cross section of the laver of red oil paint would look very much like this. Each tiny speck of pigment is surrounded by a binding substance, the vehicle which holds the pigment particles together to form a paint. It also provides the adhesion to hold the paint onto the painting surface. Gum is the binder in water colours, linseed oil in oil paints, etc.

Let us now isolate just one of the pigment particles and consider what takes place when light arrives at its surface.

The red light reflected from just one tiny particle would be difficult to see, but combine thousands of such particles and the collective red light becomes easily discerni ble.

There is one other factor to consider. When oil is used as the binder, as in this case, it forms a smooth film and acts as a rather efficient reflector of light. So some light is bounced straight off.

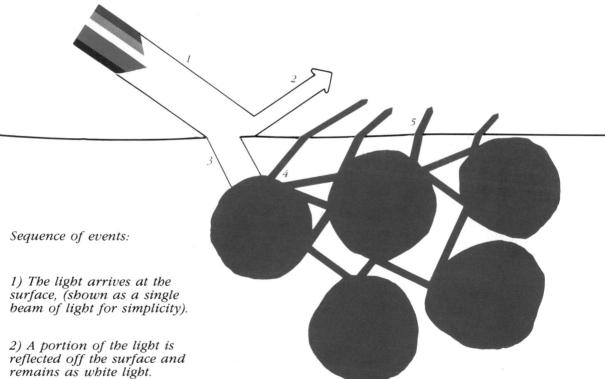

- 3) Much of the light continues on its journey and enters the oil binder, (which is clear and glassy in fresh paint).
- 4) When the light reaches the pigment particles, most of it is absorbed, apart from the red portion which is reflected.

Pigments absorb the majority of every other colour except their own.

5) The reflected red light either leaves the binding film directly or bounces off other pigment particles, before finally emerging from the paint film.

This red light combines with the reflected white light, giving an overall brighter effect.

Via the eve, this information is recorded as a red 'sensation' within an observer's brain.

4.4 Mixing the Three "Primaries"

Now that the basic mechanics of the paint film have been examined we can consider the processes within the paint layer when we physically mix colours.

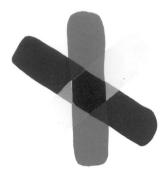

We will learn a great deal by mixing the traditional painter's 'primaries' and examining why the result is a grey, almost black colour.

1. Light that strikes the yellow pigment in the mix is absorbed apart from the yellow which is reflected.

If the yellow light reflected by the yellow pigment happens to meet up with another yellow particle, it is reflected again and is therefore temporarily safe.

If, however, it strikes a blue or red speck of pigment, it is absorbed.

2. Light arriving at the blue pigment is destroyed in the same way, with the exception of its blue component which is 'bounced off'.

3. Every colour contained in the light, with the exception of red, is absorbed by the red pigment.

Suddenly, there is no more yellow light.

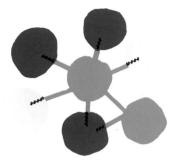

In the case of the blue light reflected by the blue pigment, it too can bounce off other blue particles, but is absorbed by either the red or the yellow. No more blue!

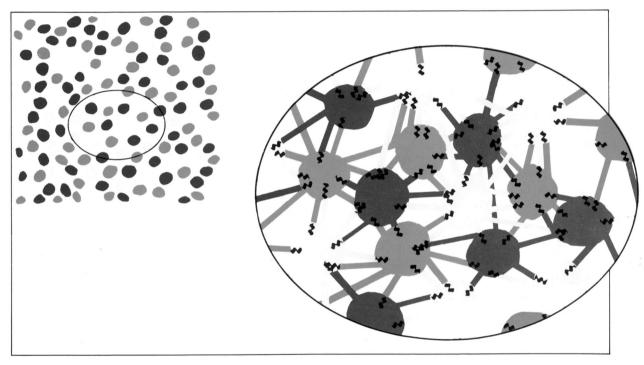

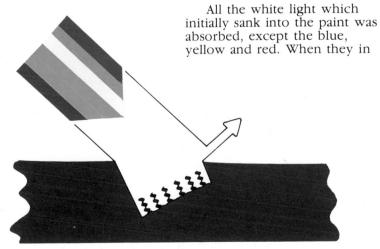

turn are absorbed, what is left? The simple answer is — nothing.

The conclusion, therefore, is that if the three traditional SUBTRACTIVE 'primaries' are mixed in equal INTENSITIES, only a minute proportion of the light energy reaching the surface is reflected, while the rest is absorbed. The result is a very dark grey, approaching black.

At this point it would be a good exercise to mix such a dark. Combine Alizarin Crimson, Ultramarine Blue and

Cadmium Yellow.

Start by mixing the three in roughly equal proportions. Do not be concerned if you

cannot obtain a dark straight away, since paints can vary enormously in intensity of colour.

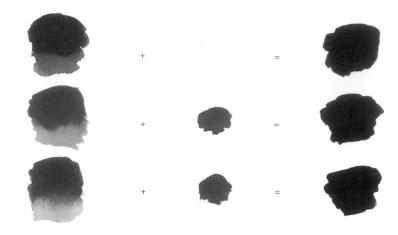

Thin a portion of the mix near its edge to see if one or even two of the 'primaries' are dominating. If they are, add small amounts of the colour or colours being swamped until you have a dark, blackish grey. If at first the result is an orange, add blue; if it leans towards violet, add yellow; and if greenish, add red.

By mixing the three subtractive 'primaries' in near equal intensities so much incoming light is destroyed that very little escapes.

4.5 Mixing just Two 'Primaries'

If just two PURE 'primary' colours were to be mixed, the result would be most unexpected. Take the example of a PURE yellow and a PURE blue.

Here the yellow pigment absorbs all light except the yellow.

The blue pigment likewise absorbs all but the blue portion of the light.

The next event in the sequence is that the yellow pigment absorbs all the blue light and vice-versa and the result is a **dark grey**, almost black.

But how can this be? Everyone knows that blue and yellow paint make green.

BLUE AND YELLOW DO NOT MAKE GREEN

This may seem a wild statement but in fact sets the stage for a REAL understanding

stage for a REAL understanding of colour mixing.

In this example of mixing blue and yellow, the word PURE was emphasised, PURE yellow and PURE blue. Two such pure 'primaries' WOULD make a very dark grey.

The mix was in fact theoretical because we do not, as yet, have pigments that are

as yet, have pigments that are pure in hue. There is no such substance as a yellow paint which reflects only 'yellow' wavelengths.

Nor do we have a blue paint that is entirely pure.

The Painters' Primary Colours Do Not Exist

The present system is unable to cope — it leads to frustration, limited colour expression and an enormous waste of expensive paint. There is a simple answer: that is, to abandon the three primary system and replace it with an entirely different way of viewing colours — we have to change the way that we think.

- 5.1 Pigment Colour Bias
- 5.2 The Colour Bias Wheel
- 5.3 The Surviving Light
- 5.4 The Traditional View
- 5.5 The Six Principle Colours

5.1 Pigment Colour Bias

Of all the pigments available to the painter, none can be described as being absolutely pure in hue. There is simply no such thing as a pure red, yellow or blue paint.

Paints may appear as a single hue and are often described as pure, but this is inaccurate.

When we first looked at why an object appeared a certain colour, we did so in a simplified form. Let us now go back in more detail.

Up until now, we have said that a colour such as say, Cadmium Red, is created by the surface absorbing every colour except its own, in this case red.

In reality the majority of the red portion of light escapes, BUT SO TOO WILL VARYING AMOUNTS OF EVERY OTHER COLOUR CONTAINED IN THE LIGHT.

The red light is reflected together with a relatively large amount of the orange light. Some yellow escapes and a

small amount of green, blue and violet. Every spectrum colour is represented in the final colour that we perceive.

The two major components reflected are red and orange, while the rest of the colours are found in relatively tiny amounts.

2

3

This is another way to demonstrate the content of reflected colours; the columns represent in an approximate way the 'stray' colours reflected along with the red from a layer of Cadmium Red paint.

If we were to draw a line through the chart, we could basically say that all colours below it leave in the form of white light, since an equal amount of each spectral colour produces white light.

Other paint colours can be similarly described. Ultramarine Blue for example

is a pigment which strongly reflects blue as well as some

This diagram represents, in a simplified way, the colours reflected from a layer of Cadmium Red paint.

violet and a small amount of green.

These are the six colours we chose earlier for our basic palette and which will be used

in the following mixing exercises.

Cadmium Red — red. orange and a small amount of plus violet and a touch of violet.

Alizarin Crimson — red. orange.

Ultramarine — reflects blue, some violet and a little green.

Cerulean Blue — blue with lesser amounts of green and violet.

Lemon Yellow — yellow, some green and a little orange.

Cadmium Yellow yellow, some orange and to a lesser extent green.

5.2 The Colour Bias Wheel

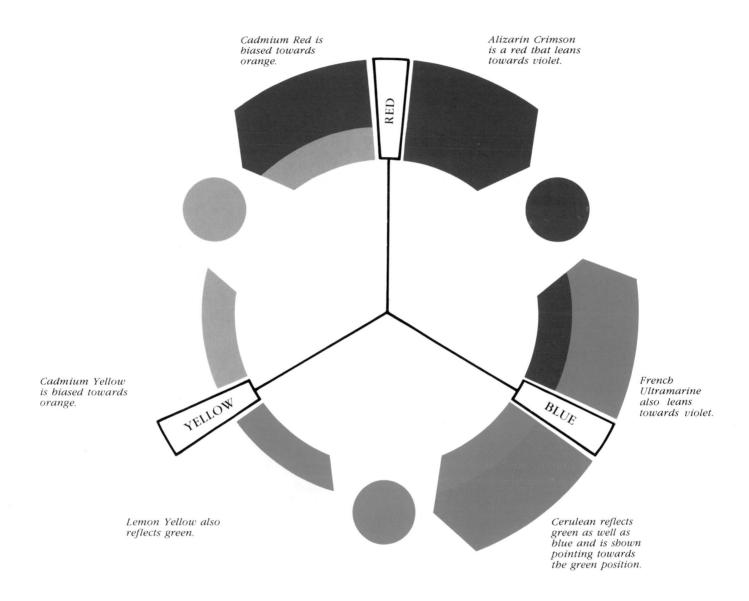

To simplify matters initially, we need only consider the two main colours involved. Don't forget about the third colour though because it will reappear later. The two reds, yellows and

blues we analysed adopt these positions when formed into a colour wheel (the bias wheel we used earlier). As the name implies the wheel indicates the leaning or bias of each colour.

5.3 The Surviving Light

Green

Cerulean Blue

Lemon Yellow

We have already found that if a PURE yellow and a PURE blue were mixed they would result in a dark grey, not a green.

Let's now examine very closely what happens when IMPURE yellow and blue

pigments are mixed, for this example Lemon Yellow and Cerulean Blue.

Broadly speaking we can say that Lemon Yellow absorbs all colours in the light except yellow and a certain amount of green. The Cerulean Blue

reflects blue and also some green.

For now we will ignore the small amount of orange in the yellow and the violet in the blue

The yellow and the green reflected by the Lemon Yellow pigment are treated quite differently as they strike the Cerulean Blue. The yellow is absorbed because a blue surface absorbs yellow. But the green is reflected because here we have a type of blue which also reflects green.

Cerulean Blue pigment reflects both blue and green light and when the two arrive together at the yellow particles, the blue is absorbed, (as yellow destroys blue) but the green is reflected because Lemon Yellow is a type of yellow which rejects green.

Some of the green light is reflected immediately by these two colours while the remainder 'bounces' around

between the blue and yellow pigments unable to find an outlet. Eventually it makes its way to the surface of the paint film and escapes.

Can you see then that the yellow and blue do not themselves mix into a green? It is simply that green is the only colour able to survive the

subtractive process; and it is present because neither the yellow nor the blue were PURE 'primaries'.

Or put another way, we can say that we are able to mix green from blue and yellow because both colours carry green as an 'impurity'.

Violet

Alizarin Crimson

Ultramarine Blue

In the same way that yellow and blue do not themselves combine to form green, so red and blue do not themselves make violet.

If the blue and red both 'carry' or reflect violet, the

violet will escape when the red and blue are mixed. The red and blue actually 'cancel each other out' or subtractively absorb one another in an even mix.

Orange

Cadmium Yellow

Cadmium Red

Similarly a mix of red and yellow will only produce orange if they both carry orange as an 'impurity'. Pure red and pure yellow, if we had them, would be quite incapable of producing an orange.

5.4 The Traditional View

The subtractive 'primaries' have been given pride of place on countless colour wheels, as

if these colours actually existed. We now know that they do not exist, either in pigment form or in nature.

For this reason the red, yellow and blue positions have been left blank in the colour bias wheel on page 39. We have neither paint, ink, nor dye with which to colour them.

Definitions of a Primary Colour

Red, yellow and blue are commonly described as being 'primary' in nature because (1) they cannot be mixed from other colours and (2) through mixing they produce all other colours.

As we have made use of them for so long, we should examine these definitions.

True, neither red, yellow or blue can be mixed from any combination of other colours. But neither, for example, can green. It has to be carried almost as an

'impurity' by the yellow and blue. Similarly orange and violet have to be introduced by the 'primaries'. They are all equally independent as they too cannot be mixed from other colours.

When we mix a green, we SAY that we are producing it from blue and yellow. It would certainly seem to be the case that yellow and blue combine to give a new colour.

For what seemed like perfectly logical reasons we have relegated green, violet and orange to the position of 'secondary' colours.

If we define a primary as a colour that cannot be mixed from others, then with our new information, we are compelled to include green, violet and orange.

To define red, yellow and blue as primaries is only true in a rough and ready way — leading to rough and ready colour mixing skills.

2. THROUGH MIXING THE PRIMARIES, ALL OTHER COLOURS CAN BE PRODUCED.

Again, this is patently incorrect.

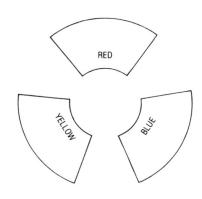

It all stems from the fact that the 'primaries' have been considered as being pure colours — whereas in fact such colours do not exist. We might think that we can imagine what they would look like, but as yet we have not seen them. They are only ideas.

To go back to page 13 and the present thinking behind the primary system of colour mixing:

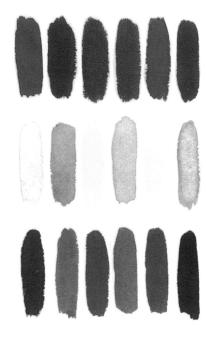

• If the red, yellow and blue were chosen carefully all would be fine — but this is obviously not the case.

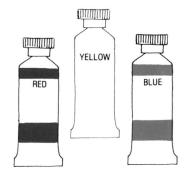

• One day the paint manufacturers will give us really pure primaries and then we will be able to produce a complete range from one tube each of red, yellow and blue.

If the day ever does arrive when we discover pigments that only reflect a very limited range of 'colour waves', they will be virtually useless for mixing purposes since we will only ever get darks from them.

The Printers' Primaries

It is easy to see how the three primary system has survived for so long. As a basis from which to proceed it appears to be quite logical and has certainly been better than no system at all.

The printing industry long ago decided on its own set of primaries:

Magenta — a red leaning towards violet.
Cyan — a greenish blue.
Yellow — without a strong leaning either way.

In terms of the widest range of colour mixes that will result from the minimum number of coloured inks, these 'primaries' (with the addition of black), are certainly most successful. Unfortunately the actual range of colours that they can produce is limited. Mixed oranges, for example, are always dull and the range is restricted in other areas.

To compensate for these limitations the printer is compelled to introduce additional colours if the range needs to be extended.

5.5 The Six Principle Colours

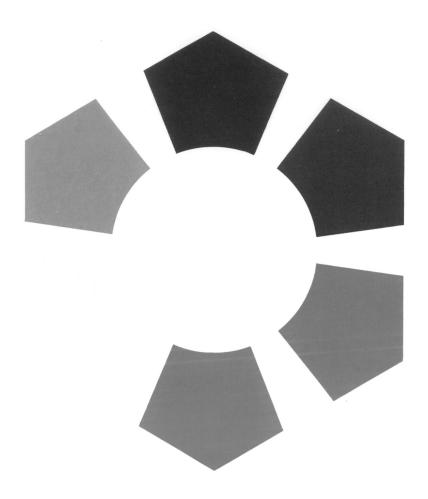

Reliance on the traditional three primary system has failed to guide the artist attempting accurate colour mixing.

But there is a simple answer: abandon the three primary system and replace it with an entirely different way of thinking about colour.

By treating the above colours on an equal basis rather than defining them as primaries and secondaries and by taking into account their presence in a mix, we can make logical decisions about selecting colours to mix.

If, for example, we no

longer think of the 'primaries' yellow and blue producing the 'secondary' green, but how much green is being carried by a particular yellow and blue we can make dramatic improvements in our colour mixing results. In this example the green content must be given as much importance as the blue and yellow — and even more thought.

For too long now we have emphasised the selection of contributing colours to the exclusion of any examination of why particular results emerge.

Exploring the Basic Palette's Range

We will now start to explore the vast range of colours that are obtainable from our six colour types, orange-red, violet-red, violet-blue, green-blue, green-yellow and orange-yellow.

- **6.1 Selecting Contributing Colours**
- 6.2 Exploring the Clear Colours
- 6.3 Colour Wheel A Clear Colours
- 6.4 Neutralized Colours
- 6.5 Colour Wheel B
- 6.6 Colour Wheel C
- 6.7 Colour Wheel D

6.8 Reds, Yellows and Blues

6.9 The Exercises

6.1 Selecting Contributing Colours

Violets

We will now take a closer look at the violets that were mixed on page 16, this time with a view to finding out just what happens WITHIN the mix.

The first mix was a combination of an 'orange-red' and a 'green-blue'. Cadmium Red and Cerulean Blue fit these descriptions.

The resulting mix is hardly a pure violet; in fact it is nearer to a dull brown. What went wrong? After all, a blue and a red were mixed and they should have made violet.

The answer lies with the particular colours we chose. Cadmium Red we know reflects red efficiently, orange moderately well and violet very inefficiently. Cerulean Blue reflects blue very well, is reasonably successful at reflecting green, but a poor performer when it comes to violet.

A breakdown of the colour bias wheel shows that neither Cadmium Red nor Cerulean Blue was a suitable contributing colour for mixing a violet. Both point AWAY from the violet position.

When the two paints are unleashed inside the mix they set about attacking each other's reflected lights.
Cadmium Red pigment absorbs the blue and green light but reflects the small amount of

violet coming from the Cerulean Blue. Cerulean Blue absorbs the red and orange but not the violet sent to it by the Cadmium Red.

The final result is a very subdued neutral with a slight

leaning towards violet. It is subdued because nearly all the light entering the paint film has been absorbed and it leans towards violet because both pigments have reflected their small violet content.

This time we will select the contributing colours a little more carefully and go for a blue which is known to be a reasonable reflector of violet, while staying with the Cadmium Red.

The blue, red, orange and

green reflected by these pigments are soon absorbed, leaving only the violet. A great deal of light is lost inside this mix, but a reasonable amount of violet manages to escape. Much more so in this mix since Ultramarine Blue is an

efficient reflector of violet.

The colour bias wheel predicts this result: one arrow points towards the violet position and the other points away from it.

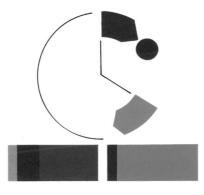

Alternatively the violet can be introduced by the red. Alizarin Crimson is a red biased towards violet. The characteristics of the contributing colours will make changes to the resulting violet, but in both cases the colour

will be subdued. Not as dull as the first mix (Cerulean Blue and Cadmium Red) but not yet clear.

Alizarin Crimson and Ultramarine Blue produce one of the purest mixed violets, and for this reason:

The light that enters this mix is robbed of its blue, red,

green and orange content, but the violet, which is reflected by both pigments, escapes unhindered. All we see of the original light which entered the paint film is that part of

the spectrum common to both contributing colours — violet.

As the bias wheel indicates, a relatively pure violet can be expected as both arrows point TOWARDS the violet position.

SUMMARY

The violet colour resulting from a mixture of red and blue is essentially just the residue of the light which entered the paint film.

Depending on the amount of light destroyed during the subtractive process, the final colour will be lighter or darker.

There are two factors involved in every mix, the amount of light that emerges and the colour of that light.

and the colour of that light.

There is, of course, a certain amount of light reflected from the paint surface, light which does not penetrate the paint and this will lighten the result.

It should now be clear why such care must be taken with the selection of contributing colours. You will undoubtedly not be alone if you have struggled to mix a violet with just any red and blue that comes to hand.

The Cadmium
Red/Cerulean Blue mix
allowed very little of the
incoming light to escape —
giving a dull, slightly violet
grey.

More violet light was able to surface when either Ultramarine or the Alizarin were used to introduce the violet. In the final mix the result was lighter and more violet due to the amount and nature of the light that was able to surface.

Greens

We now know in advance that a Cadmium Yellow and Ultramarine Blue mix will not result in a pure green. Both are poor, inefficient reflectors of green and in destroying nearly all of each other's colour, much of the original light striking the Ultramarine/Cadmium Yellow paint film is lost. The final colour is a very subdued greygreen; grey because very little light escapes the mix and

green because that is the only surviving colour.

Again the colour bias wheel indicates the likely result; both arrows point away from the green position.

Cadmium Yellow and Cerulean Blue, by comparison, mix into a clearer green, but it is still somewhat murky as the Cadmium Yellow is not the

best choice as a reflector of green. Its partner, Cerulean Blue, provides most of the green.

As an alternative, Lemon Yellow can be used as a means of introducing a little extra green. Still a murky green, but

slightly different to the previous mix due to the different natures of the contributing colours.

The bias wheel indicates that Lemon Yellow and Cerulean Blue are the best suited colours from our limited palette to give a clear green. Both are strong reflectors of that hue. After a certain

amount of the light has been absorbed — the blue, yellow, orange and violet components — enough escapes to give both brightness and 'greenness' to the mix.

Oranges

Once again we will deliberately start with a poor selection. Neither Crimson

which is the mutually reflected orange. The result therefore is a dull, greyed-orange.

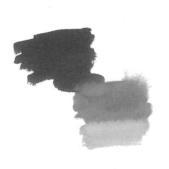

reflect a reasonable amount of orange, but the mix is still dull because of the limited amount of light which is able to escape.

Cadmium Red will introduce orange to the mix. As the yellow used is a poor

carrier of orange, the result is still subdued.

A CLEAR ORANGE

In the final exercise the contributing colours, Cadmium Red and Cadmium Yellow, have been chosen because

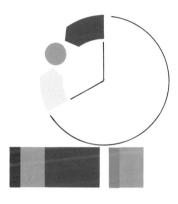

they are strong reflectors of orange.

The resulting bright orange represents the sole segment of the original light to survive the melee inside the paint film.

Note: The distinction between the various oranges will be more obvious if you mix them using your own paints. As mentioned elsewhere, conventional printing techniques make it difficult to highlight the differences.

Colour Mixing is a Thinking Process

The painter with an understanding of the fundamentals of subtractive mixing is in a position to obtain the desired results quickly and without wasting paint.

Once the distinctions between the different types of contributing colour are appreciated, the painter can fully control colour mixing. Now that you have taken the trouble to actually LOOK INSIDE the paint layer in order to understand the mechanics of paint mixing, you will have laid the ground work for quickly obtaining any desired colour.

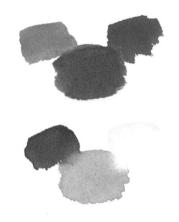

Varying the Proportions

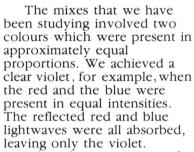

When the proportions of the two pigments are varied, we can expect quite different reactions to take place.

If the amount of red pigment in the mix is increased, there will be insufficient blue pigment present to entirely destroy the

Point of equilibrium.

reflected red and orange light. The result will be a red with a slight leaning towards violet. You can see this in the first few boxes of the exercise on page 52. As the blue content in that range of mixes is increased, it is able to destroy more and more of the light being reflected by the red.

About the centre of the range, a point of equilibrium is reached where all reflected light is destroyed, apart from the violet.

The mix moves towards blue as more of that colour is added. Now it is the red's turn to be swamped. More of the blue and green light reflected

Now it is the turn of the red to become swamped.

by the blue pigment is able to escape and mingle with the violet light. There were simply not enough particles of red pigment in the mix to physically cope with the large amounts of blue light.

A similar situation will exist wherever two (or more) colours are combined in unequal proportions. A green mixed from a combination of blue and yellow, for example, will become a blue-green if more blue paint is added, simply because the yellow pigment will not be able to destroy all of the blue light.

Moving towards blue-green.

More blue is added.

6.2 Exploring the Clear Colours

Clear Violets

In this section we will concentrate on colours in terms of their suitability to produce clear results. But bear in mind that duller mixes are no less useful and will be studied later.

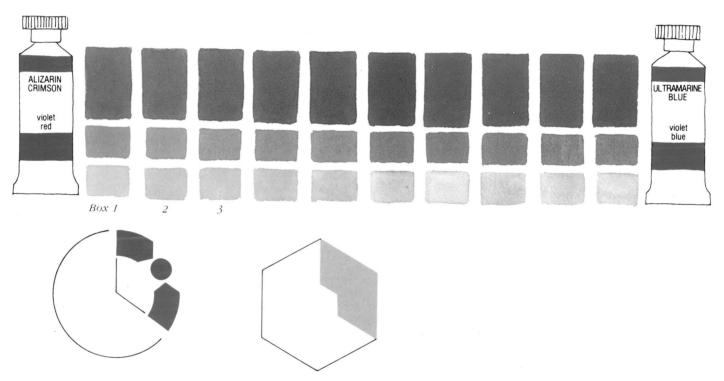

The result is forecast by the colour bias wheel.

This range of violets can be found on colour wheel A, page 54.

Alizarin Crimson and Ultramarine Blue, we know, give a pure violet — one of the purest of all mixed violets in fact.

In the above exercise, Alizarin Crimson is placed straight from the tube into Box 1. From Box 2 onwards, more and more Ultramarine is progressively added and the Alizarin Crimson gradually phased out until eventually pure Ultramarine emerges in the last box. At the mid-point is a violet leaning neither towards the blue nor the red.

Each colour has been progressively lightened to form two tints. The water colourist would normally apply the paint thinly, allowing the whiteness of the paper to provide the tint. The oil or acrylic painter usually adds white paint.

Clear Greens

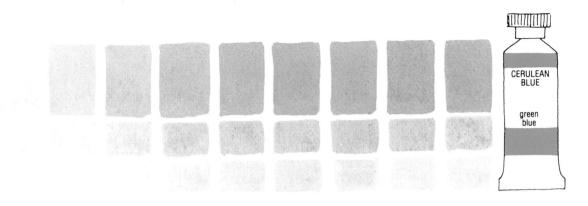

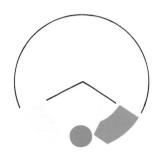

By following the same approach, a range of greens moving from blue-greens to yellow-greens can be created.

This range of greens is found on colour wheel A, page 54.

Clear Oranges

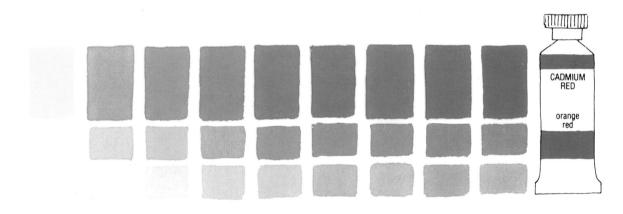

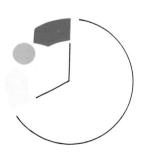

See colour wheel A on the following page.

Brighter oranges can be achieved using these two Cadmium colours than are shown here, due to the limitations of conventional colour printing technique.

As mentioned elsewhere in

As mentioned elsewhere in the book, I suggest that you reproduce these exercises yourself in order to gain the maximum benefit.

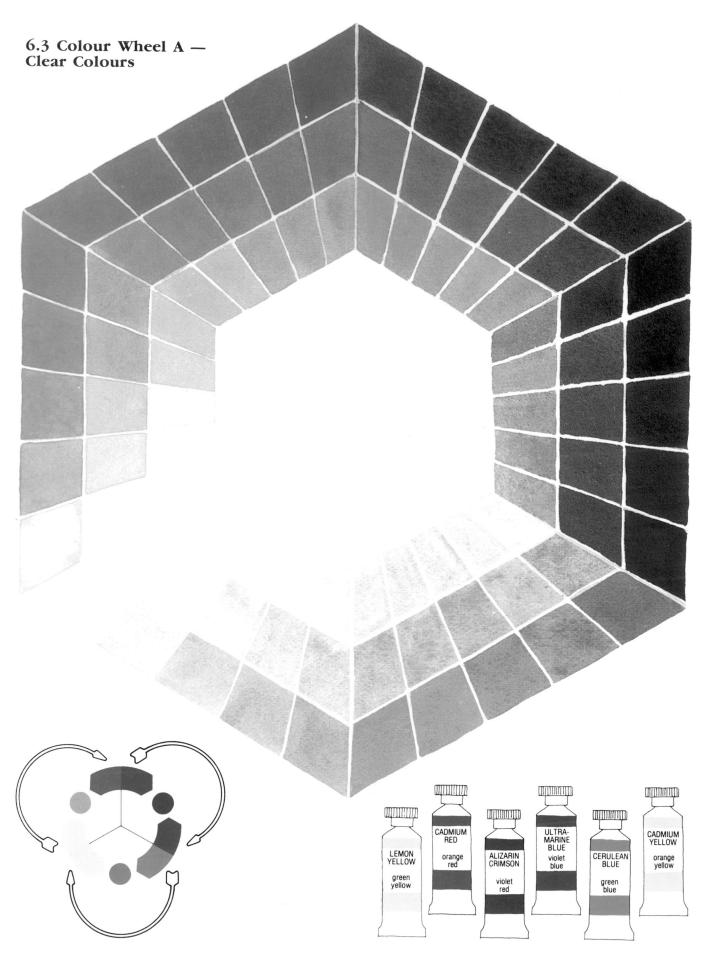

6.4 Neutralized Colours

Violets

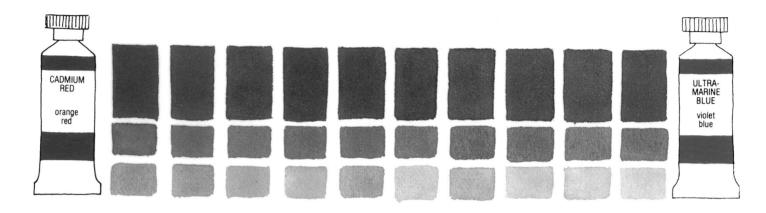

This type of red points away from the violet position and we can therefore expect dull violets.

See page 61 for the place of this range on another of the wheels (colour wheel B).

During the initial search for clear violets, greens and oranges we tried contributing colours that proved to be unsuccessful. Cadmium Red and Cerulean Blue, for example, made a very poor violet. But the results were only 'unsuccessful' in as much as they were not clear hues. They are nevertheless interesting and of equal importance to the painter.

Let us turn back and explore the 'unsuccessful' mixes and their tints. The results are recorded on a series of colour wheels (page 61 to 63 which highlight the separate results.

A diagram representing the colour bias wheel is shown with each exercise.

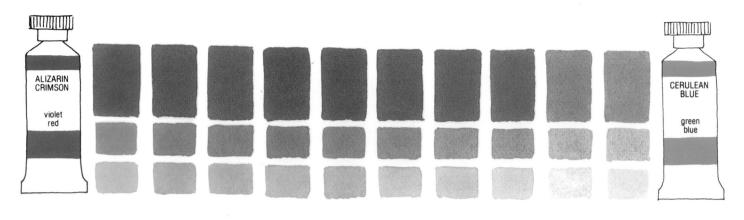

Alizarin Crimson and Cerulean Blue produce another quite different series of dull reds, violets and blues.

See Colour Wheel C — page 62.

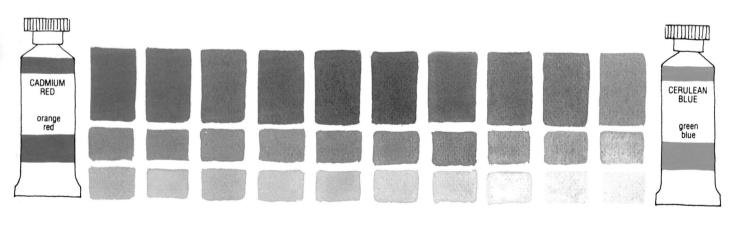

As expected, the dullest results come from a combination of Cadmium Red and Cerulean Blue.

Colour Wheel D — page 63.

Greens

Many paintings look very stilted because the greens lack variation.

Too often artists rely on manufactured, pre-mixed greens which seem to inhibit any desire to mix a wider variety and add interest to the work.

Bear in mind that many of these manufactured green mixes contain poor ingredients, like Chrome Yellow, that fade or change in some other way and eventually spoil the colour.

At this point you are probably able to look at the bias wheel before each exercise and anticipate the 'type' of colour that will emerge from the mixes.

Before

After

Some pre-mixed greens will change with time, others are often simple mixes that you could easily produce yourself.

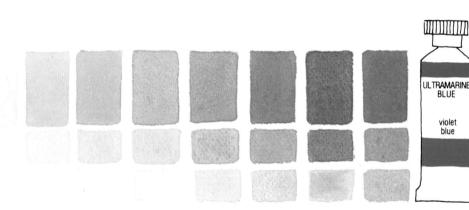

Soft and subdued greens result from a Lemon Yellow/Ultramarine Blue combination.

See Colour wheel B.

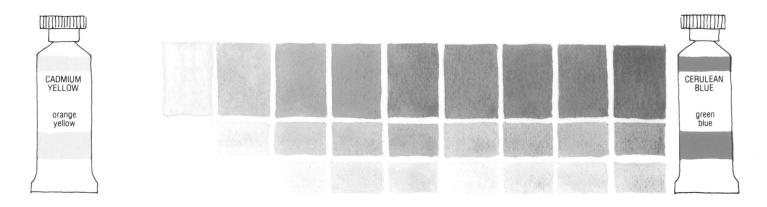

Cadmium Yellow Pale and Cerulean Blue produce slightly brash greens.

See colour wheel C.

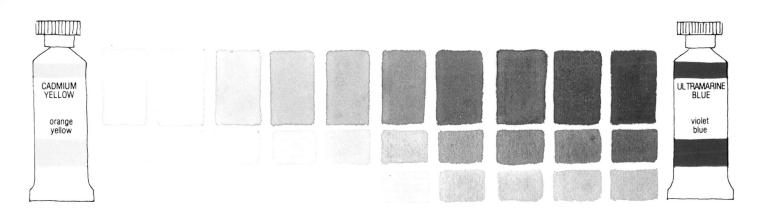

Not surprisingly, two colours reflecting as little green as Cadmium Yellow Pale and Ultramarine Blue produce some especially greyed or neutralised greens.

See colour wheel D.

Oranges

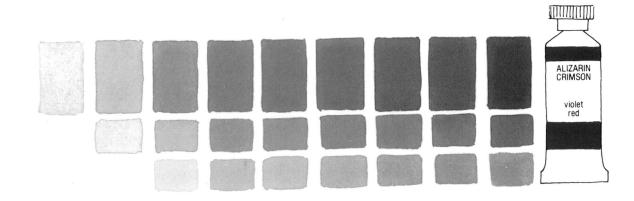

The painter can produce quite strong, brassy colours with Cadmium Yellow Pale and Alizarin Crimson.

See colour wheel C.

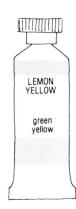

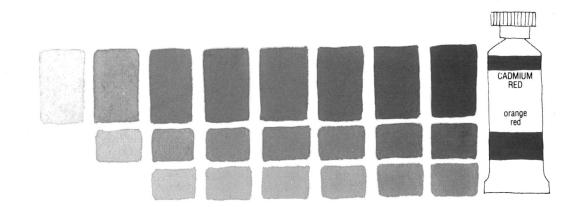

Soft, warmer oranges emerge from Cadmium Red and Lemon Yellow.

See colour wheel B.

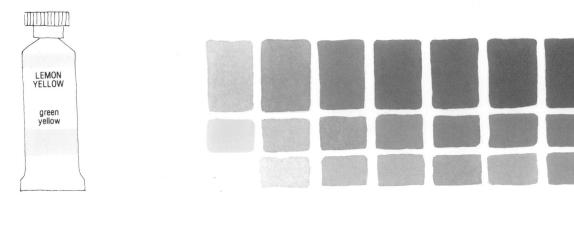

Since neither Alizarin Crimson nor Lemon Yellow reflect much orange, they can be expected to produce subdued hues. ALIZARIN CRIMSON

violet

See colour wheel D.

SUMMARY

If we carefully select our contributing colours, we can create clear colours and a wide range of valuable, neutralised hues.

There are purer, brighter colours available straight from the tube or pan: Cobalt Violet, for example, is a more vivid colour than the violet mixed from Alizarin Crimson and Ultramarine Blue; Cadmium Orange is brighter than any mixed orange, and Viridian is a clearer, brighter green than we can ever mix.

These and other alternatives can certainly have a place in the painter's palette, but because they are so bright, many painters find that they need to be desaturated slightly before they can be used.

If you habitually lighten, darken, or in some other way modify the brightness of such colours, you are in effect producing hues easily mixed from our limited palette.

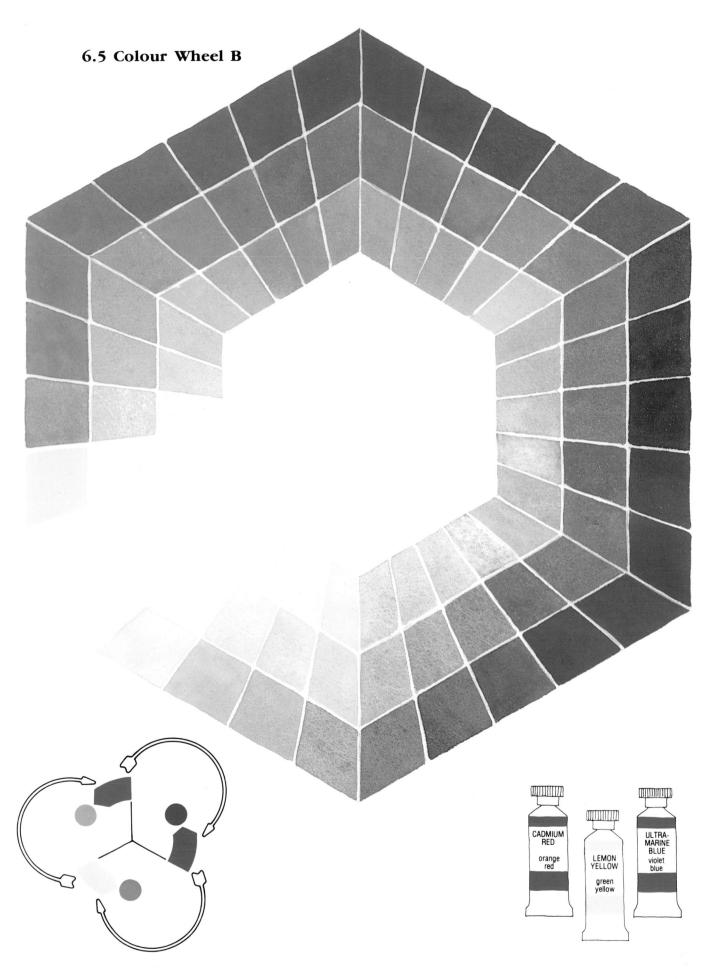

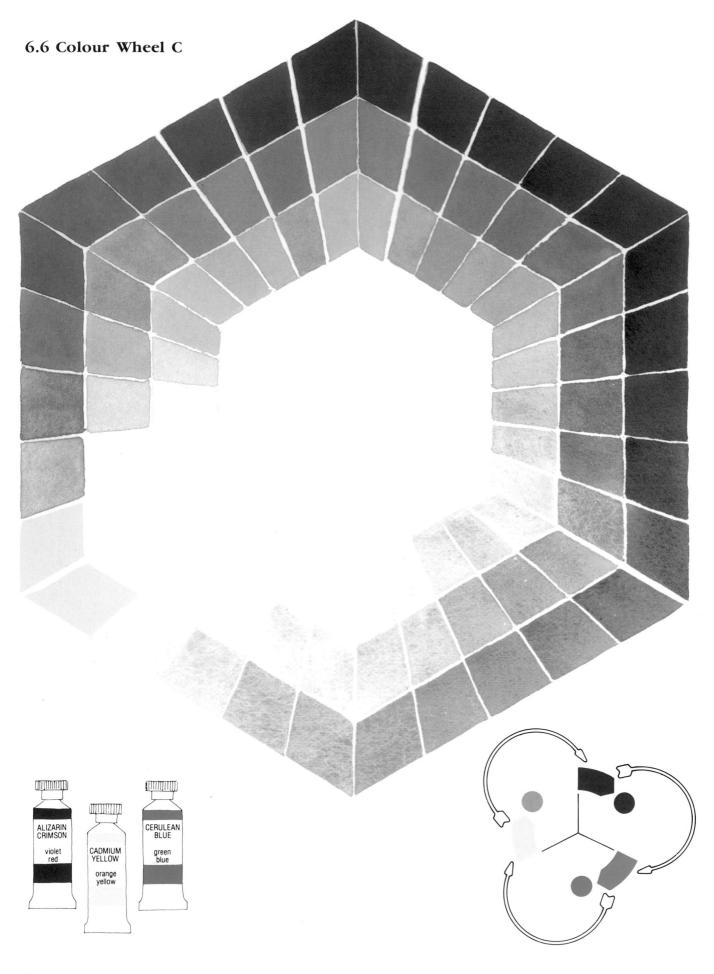

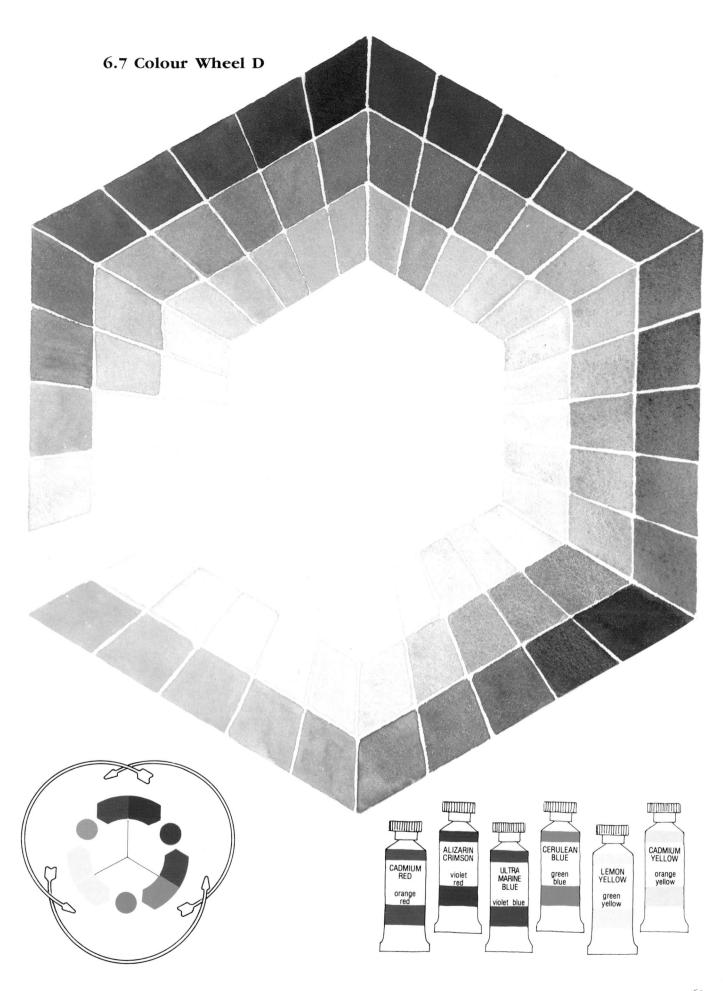

6.8 Reds, Yellows and Blues

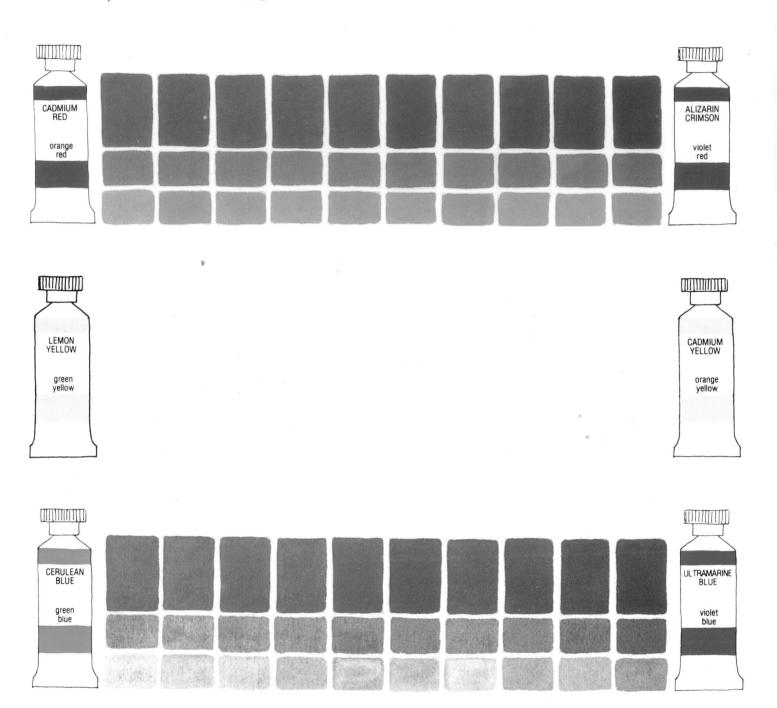

The range of reds, yellows and blues at our disposal with the six colour palette can be easily extended by mixing each pair of the same hue together — Cadmium Red with the colours can very often Alizarin Crimson, etc. Even though the variation between each box in the exercises is slight, it is definitely noticeable such mix is neutralized a little across the range.

Some of these base colours, particularly Cadmium Red and French Ultramarine, can look a little too raw on their own and. this very slight neutralizing of make them more acceptable in a piece of work.

If we think about it, every because the bias of each

colour subtracts some light.

In the case of an Alizarin Crimson and Cadmium Red mix, for example, the violet and orange biases destroy some of the brightness and soften the result.

6.9 The Exercises

The mixing exercises shown in this book are intended as a guide only. In order to fully explore the range possible in your own medium, (oils, water colour, pastels etc.), it is strongly suggested that you carry out the exercises yourself, for there can be surprising differences. A mixed orange in water

colour, for example, might look at variance with the result in oils using the same colours. There are also discrepancies between manufacturers in the character of colours of the same name. Work with your own chosen range of materials and use the illustrations as only a guide to the type of result that you can expect.

Do not worry if the transition of your colours isn't smooth. It is not an easy feat to produce gradually changing colours. All that matters is that you can see why each mix is different.

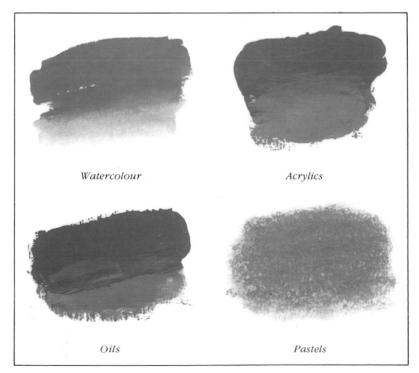

There will be differences between the various media.

Cadmium Red, manufacturer A.

Cadmium Red, manufacturer

There can be marked variations between different manufacturer's products.

		,		

Greys and Neutral Colours

A colour will set about destroying its complementary partner. We can use this fact to produce subtle neutrals and greys.

- 7.1 Greys and Neutrals from the Complementaries
- 7.2 Yellow/Violet
- 7.3 Blue/Orange
- 7.4 Red/Green
- 7.5 Other Complementary Pairs
- 7.6 Colour Wheel E
- 7.7 Colour Wheel F

7.1 Greys and Neutrals from the Complementaries

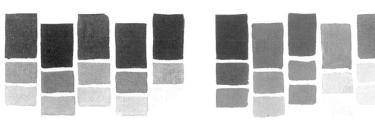

Greys are darks or nondescript colours that do not have a leaning towards any particular hue. Neutrals are darkened or dulled hues, such as darkened red or green for example.

When red, yellow and blue — traditionally thought of as the painter's 'primaries' — are combined, the subtractive process destroys almost all of the light and the mix begins to move towards black.

If the intensities of the three 'primaries' are all equally balanced, they blend into a very dark grey, approaching black. Remember, the balance refers to intensity and not the actual quantities of paint. Intensity varies from one paint to another.

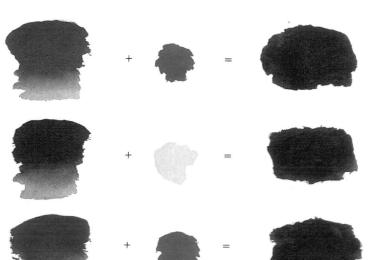

When we were attempting to mix a really dark colour, approaching black (page 34), we found that if the mix was not quite dark enough we could add another colour to darken it.

If it was rather orange we could introduce a little blue, if violet, yellow, and if it was on the green side, a little red would darken it.

It is unimportant in this exercise that the red, yellow and blue will not be pure hues, since the various lights that they each reflect will be absorbed by one or other of their partners in the mix.

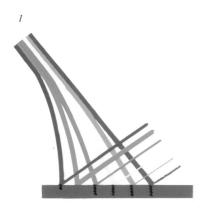

Let's look at the first example — adding blue to orange. We now know that there is no such thing as a pure blue paint. The blues that we use also reflect other colours, most importantly green and violet. Much of the green and violet light will be absorbed by the blue, but enough will escape for us to be able to use this hue as a base colour when mixing either green or violet.

Sufficient blue, green and violet is reflected by any blue pigment to make them important factors to consider when mixing.

But remember the other colours that are also involved: the red, orange and yellow. Tiny amounts of these colours are reflected, while the rest is ABSORBED.

The blue is particularly good at absorbing ORANGE light.

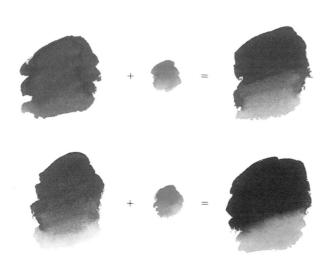

This is why the orange paint was made so much darker when the blue was added. The blue simply set about destroying the orange light before it was able to escape.

For the same reasons, orange paint added to blue destroys the blue light. The orange will reflect a tiny amount of the blue but destroy the remainder.

Blue and orange are therefore mutually destructive. These two colours appear opposite each other on our colour bias wheel, as they do on most colour wheels.

Such colour pairs are known as COMPLEMENTARIES. They are called complementaries for several reasons, one of them being that they mix into a dark grey.

For the same reasons just

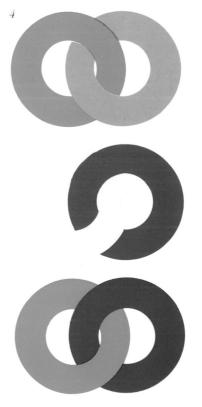

outlined, the yellow destroys the violet and the red the green in the examples, page 67.

Yellow/violet and red/green are also complementary pairs.

We can use the fact that a colour will set about destroying its complementary partner to produce some very interesting and subtle colours.

3

7.2 Yellow/Violet

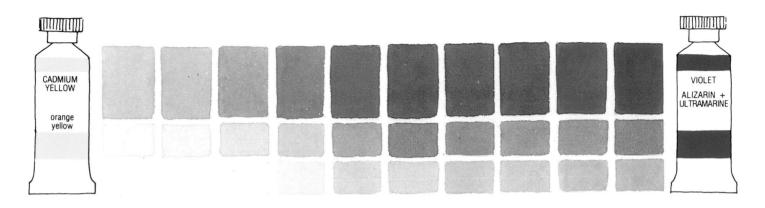

See Colour Wheel E — page 73.

Pure Cadmium Yellow Pale is used in box (1), to which a touch of the violet is added to produce box (2). By adding more and more violet the colour is taken through a series of neutralised yellows, through a coloured grey and a range of neutral violets before finally emerging in clear violet. Tints are made in the usual way. Notice how dark the middle colours become when the subtraction of light is at its greatest. The red, yellow and blue are really attacking each other with gusto!

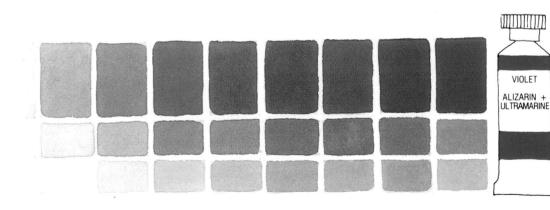

Colour Wheel E — page 73.

The second exercise calls for mixing Lemon Yellow with the violet. Note the subtle difference in results produced by the two types of yellow.

7.3 Blue/Orange

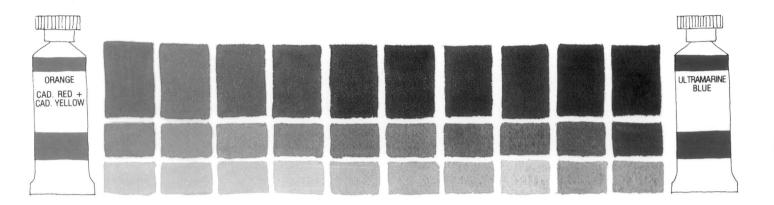

Colour Wheel E — page 73.

Blue and orange produce another grey when they approach equal intensities.

approach equal intensities.

In this exercise,
Ultramarine Blue is
progressively added to a mixed
orange (Cadmium Red and
Cadmium Yellow Pale).

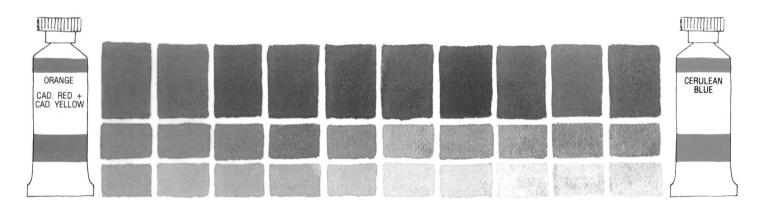

Colour Wheel E - page 73.

The blue is changed to Cerulean in the second exercise and the differences, although slight, are definitely apparent.

As expected, the Cerulean Blue adds a certain amount of green while the Ultramarine Blue exerts a violet influence.

7.4 Red/Green

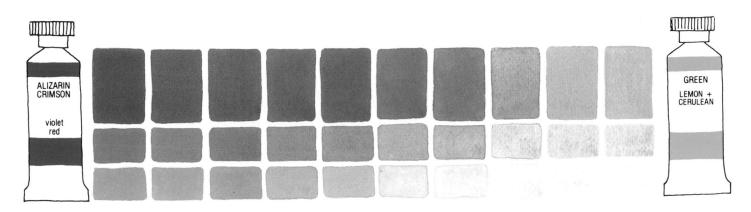

Colour Wheel E

The darks produced from a mix of Alizarin Crimson and green are particularly subtle when made into a tint.

The Cadmium Red gives a markedly warmer mix due to its orange bias which is in contrast to the cool, violet influence of the Alizarin Crimson.

Nature's range of greens seems almost limitless yet so many painters appear to close their eyes to this profuse

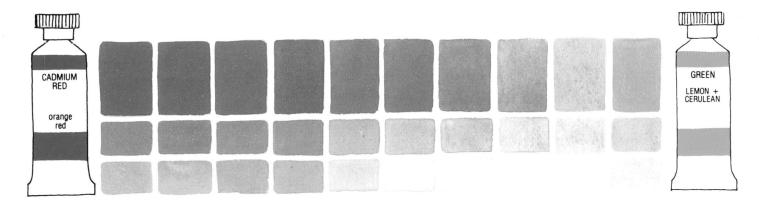

Colour Wheel E

variety and use just two or three greens in any one piece of work. These greens are usually very straightforward mixes of blue and yellow or else come directly from the tube.

Adding a little red very often gives a more authentic result — it is certainly the ideal way to neutralize or dull any green. In return, green subdues a red very satisfactorily.

7.5 Other Complementary Pairs

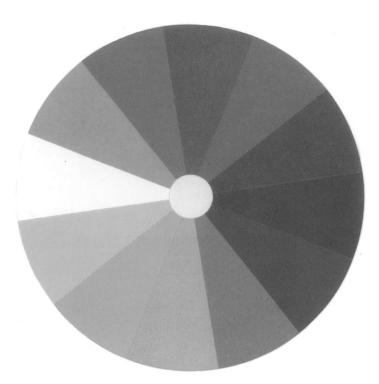

Any complementary pair can be mixed to produce a range of both neutral colours and greys. Shown here are just a few of the possible combinations.

Complementaries can be found opposite each other on many types of artist's colour wheel.

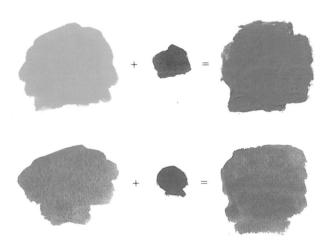

An ideal way to create a shade is to add a touch of the colour's complementary, rather than adding black. The neutralized colours and greys in this series of exercises — usually described as 'muddy' and discarded — can be used to great effect to accentuate smaller areas of bright, complementary colour.

A greyed-blue with touches of clean orange is one example. These colours are extremely important when we are seeking contrast or harmony.

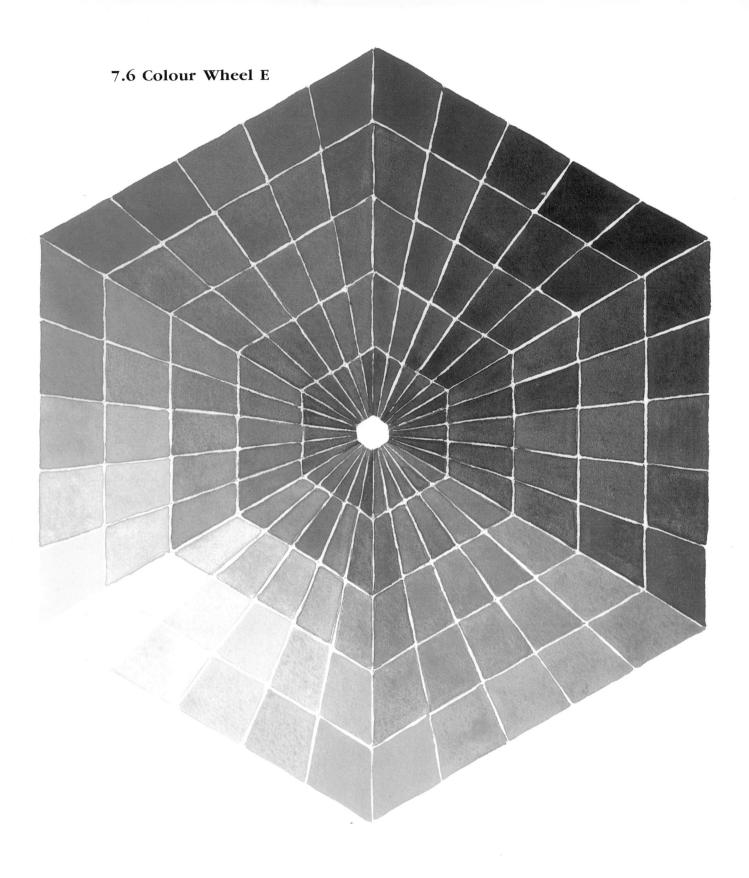

In this wheel, the exercises on mixing complementaries have all been brought together to show their relevant positions and to emphasize the profusion of neutrals and greys that can be achieved.

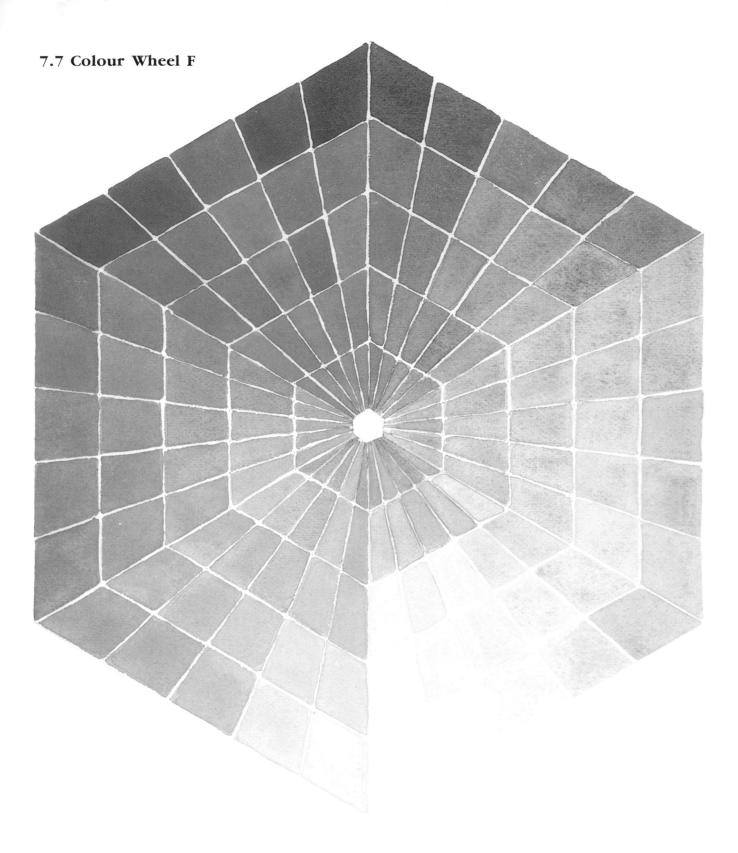

To avoid confusion the tints of these mixes have been recorded on a separate wheel.

You can easily duplicate these exercises and with practice you will be able to select a colour and take it in whichever direction you choose. Try and form a mental picture as you are mixing the colours of just what is taking place inside the paint film: why, for instance, does one blue take orange towards green while the other does not? Think through each

exercise, work out why certain colours or 'types' of colour emerge. By making notes of your observations you will gradually come to understand and control your colour mixing.

8 Transparent, Semi-Transparent and Opaque Paints

The essential differences in opacity between paints is often overlooked — yet such differences are of vital importance.

- 8.1 Paint Films
- 8.2 Transparent Colours
- 8.3 Colour Wheel G
- 8.4 Further Transparent Colours
- 8.5 Opaque Colours
- 8.6 Colour Wheel H
- 8.7 Further Opaque Colours

8.1 Paint Films

Certain colours are prized for their transparency while others are valued for their opacity. These qualities are dependent upon the careful preparation and selection of the pigments used during manufacture.

Transparent paints and inks allow underlying colours to influence the final result and in particular make it possible to create tints through their application over a white ground.

The more opaque colours are ideal for covering previous work, showing detail and adding 'body' to a piece of work.

Unfortunately many painters overlook these qualities and use transparent, semi-transparent and opaque paints as if they were all the same. Typically they attempt to cover earlier work with transparent colours or lose subtle effects through the over enthusiastic use of more opaque colours.

A carefully planned combination of opaque, semi-transparent and transparent colours in a painting creates an emphasis between the heavier opaque colours and the vibrant transparent passages.

An entirely opaque painting often looks dull and heavy

while a completely transparent piece can appear 'washed out'. The mixes produced so far are a combination of varying degrees of opacity.

The Opaque Paint Film

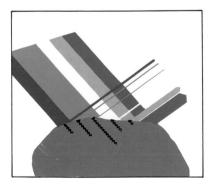

All the paint film diagrams depicted so far represent opaque paint films where the subtraction or reflection of light takes place very close to the surface of the pigment particle.

The particles of opaque pigment within the paint film prevent the light penetrating.

The Transparent Paint Film

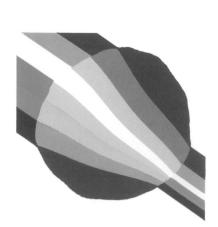

The pigment particle in transparent paint, on the other hand, allows light to travel through it without difficulty; subtraction takes place within the particle rather than close to the surface.

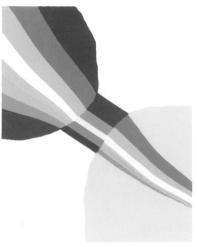

With two or more transparent colours, the subtractive process takes place in the same way as opaque pigments but within the particles rather than close to their surfaces.

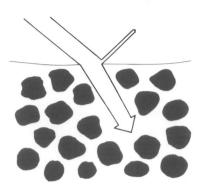

Because light passes so easily through the pigment, much of it sinks well into the paint film.

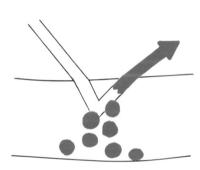

Thinly applied transparent paint will allow the light to pass easily through it and pick up any colour underneath.

Such colours are taken back to the surface of the paint and become visible.

A thickly applied layer of transparent paint allows the light to sink in deeply where its energy is dissipated and only a little is able to struggle back to the surface. The result can be a dark, almost black colour.

Semi-Transparent Paint Films

By comparison with transparent pigment, semitransparent pigment allows a smaller proportion of light to enter and reflects the rest.

8.2 Transparent Colours

Transparency Test

It is a simple matter to decide on the transparency of a particular colour.

Apply a uniformly thick layer of paint over a black line (which should be insoluble). If the line disappears the paint is obviously opaque; semitransparent paint will partly obliterate the line, and if the line shows clearly it indicates an especially clear paint.

The test illustrated here shows that Light Red, Cerulean and Cadmium Red are opaque, Cadmium Yellow semitransparent and the others transparent.

In order to increase the range of transparent hues we need to introduce several new colours to the palette.

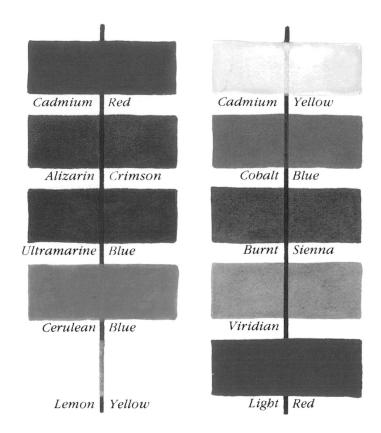

ViridianPigment Green 18

A very clear, cool, beautiful green. Extremely permanent. Very transparent and almost irridescent, it is highly valued as a glazing colour.

Applied in very thin layers, the true beauty of this colour is revealed. Unfortunately it is too often applied heavily and takes on a dull, almost blackish appearance.

It needs to be used with some care in mixes due to its rather high tinting strength. First class, quality Viridian is very difficult to manufacture and it should only be obtained from a reputable supplier.

For landscape painting in particular, a wide choice of clear, vibrant greens is essential. Viridian forms an ideal base for such greens.

In the following exercises Viridian proves its worth by giving an excellent series of transparent greens.

Cobalt Blue

Pigment Blue 28

A popular blue and a standard for many artists. Bright and very transparent, it makes an ideal glazing colour. Not strongly biased in either direction, Cobalt Blue comes close to being a pure blue. It mixes into relatively clear violets, but better greens.

Burnt Sienna

Pigment Brown 7

A well-produced Burnt Sienna is a brilliant, fiery, rich red-brown or orange-brown. It makes an excellent glazing colour because of its transparency.

Applied in a thin layer for glazing purposes Burnt Sienna displays its true beauty.

A fairly weak colour, Cobalt Blue does not help produce strong mixes. Combined with Viridian, a series of very clear blue-greens is produced. This colour is the least chalky of the red-browns and can add great depth and clarity to many mixes, especially combined with other transparent colours. Low in tinting strength, Burnt Sienna is classified either as a red or a brown.

Transparent Greens

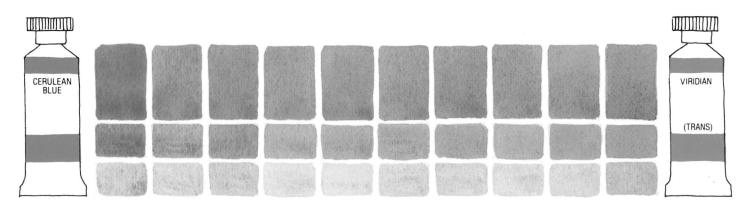

It is vital to experiment with all new colours to discover their characteristics, colour bias, transparency, etc.

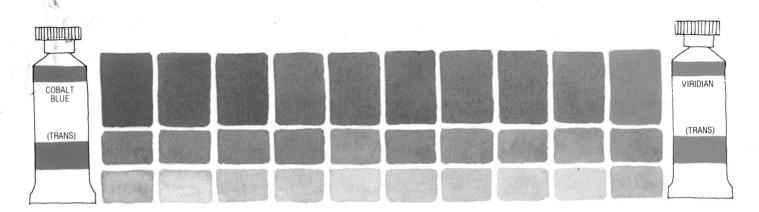

Cobalt Blue and Viridian produce fresh, clear bluegreens. This exercise reveals Cobalt Blue as a better choice than Cerulean Blue when transparency is sought (though less so when 'body' is required).

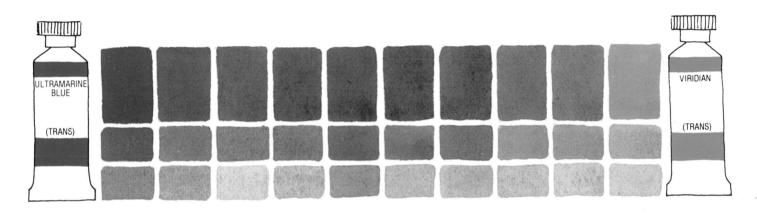

In this exercise we still find clear blue-greens but they are slightly neutralized due to the violet content of the Ultramarine Blue. The properties of the three blues — Cerulean, Ultramarine and Cobalt — will become more apparent with experience.

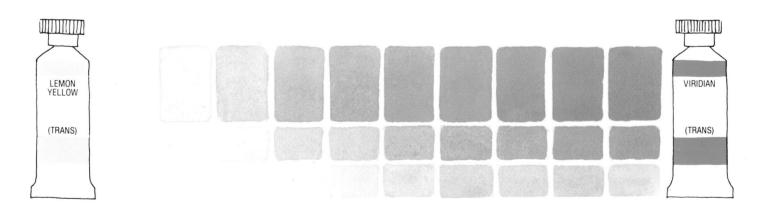

You must use a quality Lemon Yellow to obtain the relatively transparent results found here.

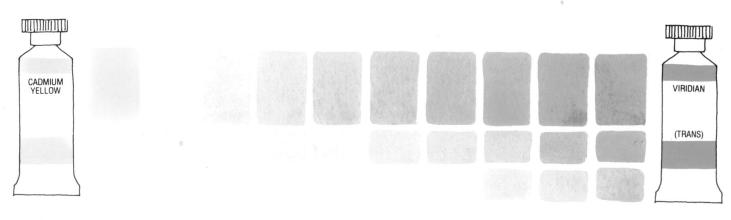

A Viridian and Cadmium Yellow mix gives the painter a variety of reasonably transparent yellow-greens, noticeably different in character to the Lemon Yellow/Viridian blend.

A well made Cadmium Yellow, although it is not in itself a transparent colour, has sufficient colour strength to be used in thin layers in order to appear transparent.

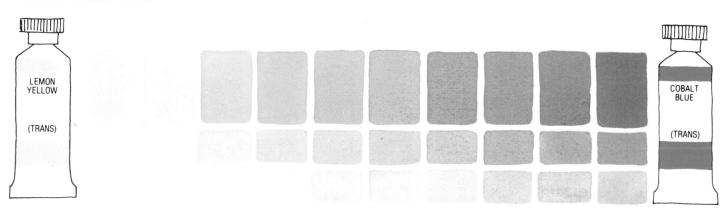

Delicate, transparent greens are made from a mix of

Lemon Yellow and Cobalt Blue.

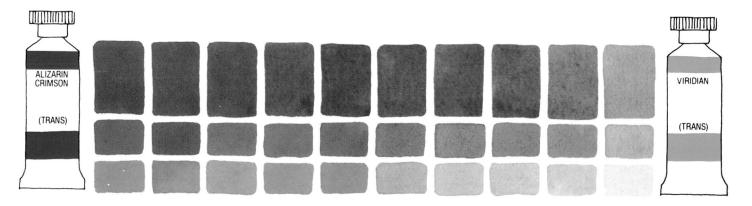

Any of the transparent greens can be dulled or neutralized simply by adding the complementary red. It is not necessary for mixing purposes to exactly match up complementaries; any red will move any green towards grey. Varying the reds or greens used, gives differing results, of

course, but the principles of subtractive mixing apply, whatever the pairing.

Alizarin Crimson is very transparent and therefore makes a wise choice for the red.

It is also, incidentally, close to the true complementary of Viridian.

This exercise illustrates the ability of Viridian and Alizarin to soften each other's abrasiveness and lessen their tendency to clash with other colours.

Neutralized hues like these come into their own when colour harmony is sought.

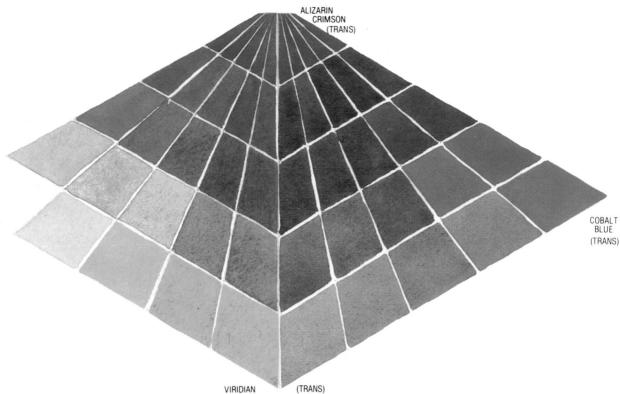

The above exercise explores the range of neutralized greens derived from mixing Alizarin Crimson with a series of transparent

greens. It also demonstrates that exact complementaries need not be chosen to neutralize a colour.

These soft, transparent

colours clearly demonstrate the enormous variety provided by even a limited palette.

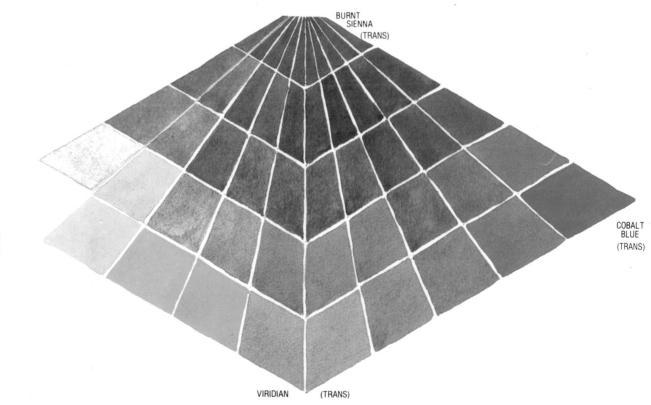

LEMON YELLOW (TRANS)

LEMON YELLOW (TRANS)

> Those greens not in a near complementary relationship with Alizarin Crimson or Burnt

Sienna still mix into useful colours, but they are more difficult to forecast.

Transparent Violets

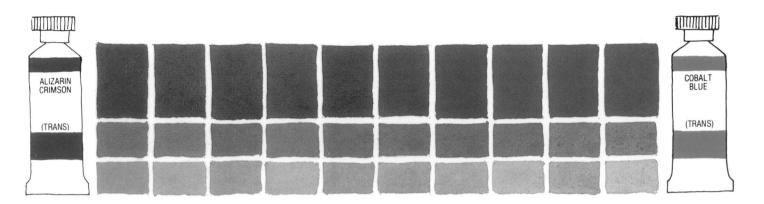

Alizarin Crimson and Ultramarine Blue, as we have seen already, form one of the purest mixed transparent violets.

Another useful series of

violets, this time slightly less intense, can be mixed from Cobalt Blue and Alizarin Crimson. (Cobalt Blue reflects violet less effectively than Ultramarine Blue.)

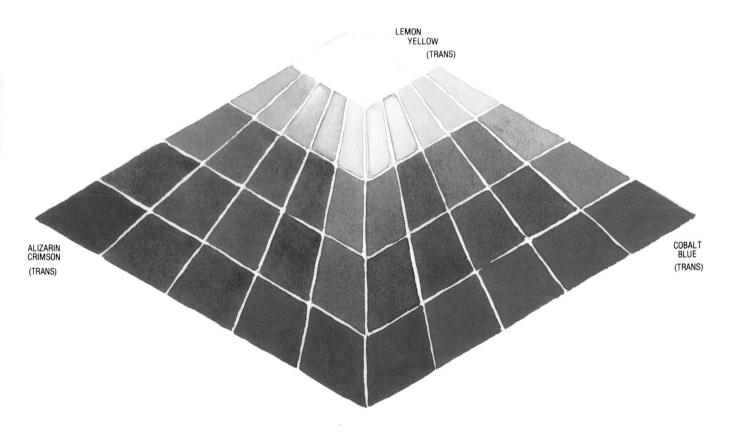

The softening effect of the Lemon Yellow is most apparent with the violet segment and dissipates as it approaches the red and blue positions.

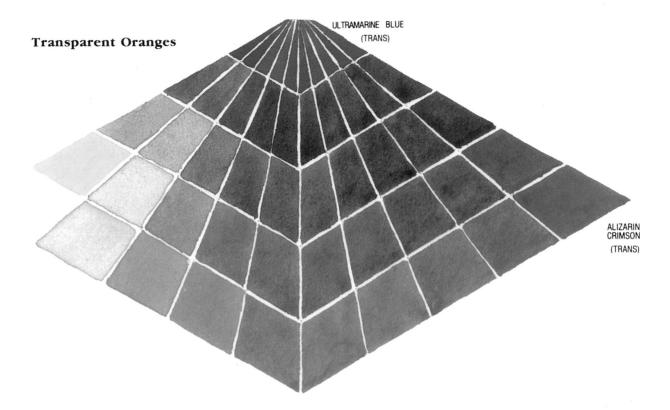

LEMON YELLOW (TRANS)

Strong, clear oranges are usually difficult to place harmoniously within a piece of work and although they certainly have a place in the painter's repertoire, their use is

regarded as rather limited.

Accordingly, we will concentrate only on the more subdued oranges.

The neutralized oranges mixed from Alizarin Crimson

and Lemon Yellow are effectively cooled further by adding blue.

Note the greying effects of the orange on the blue.

PURE TRANSPARENT ORANGES

Pure transparent oranges can be obtained but it means adding further colours, which have the following drawbacks:

1. The clearest orange-yellows and orange-reds are often powerful colours that combine to produce oranges many painters find too bright for transparent colour work.

2. Such colours are often prone to fading and can be very expensive.

It is an easy matter to add these hues to your palette and some simple tests will show their colour bias and transparency. But take care that the colours you select are lightfast because paint applied in very thin layers can be prone to fading.

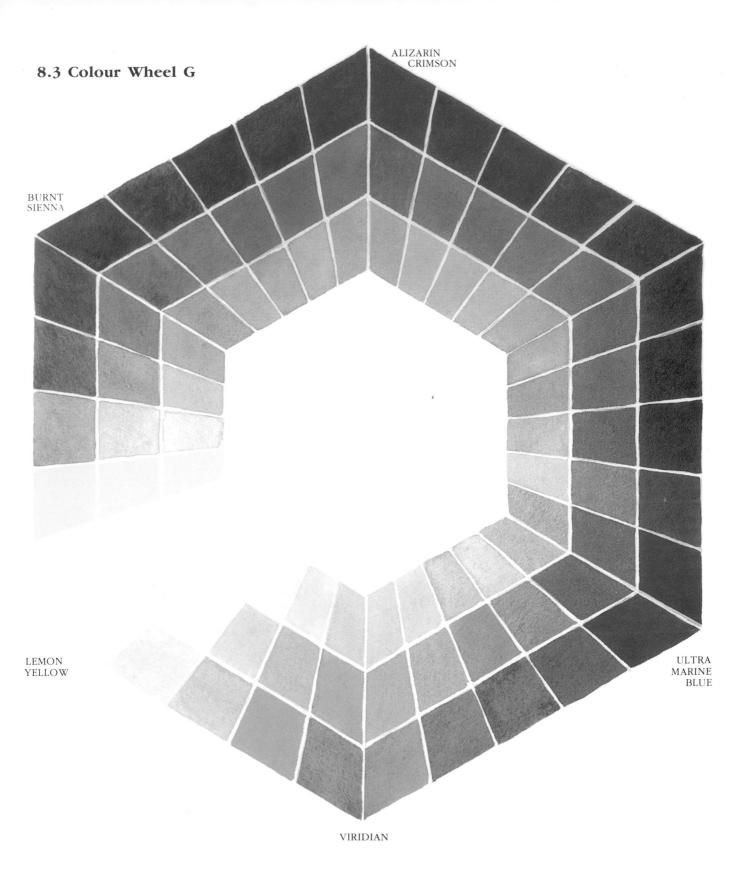

This wheel of transparent colours illustrates just one potential combination. It can be varied by, for example, removing the Burnt Sienna (for a different series of neutral

oranges), or by taking out the Viridian to give other transparent greens. Alternatively, further clear colours can be introduced replacing those used here.

8.4 Further Transparent Colours

Other suitable transparent colours include:

Quinacridone Reds

Usually sold under a variety of trade names and vague, fancy titles such as Geranium, Rose or Scarlet.

There are several types of Quinacridone compound on the market which give a wide range of exceptionally transparent reds. These clean, brilliant reds invariably have a slightly violet bias making them less suitable for mixing clear oranges.

Particularly clear and lightfast are:-

Quinacridone Magenta — Pigment Red 122 Quinacridone Red — Pigment Red 192 Quinacridone Scarlet — Pigment Red 207

Phthalocyanine Blue Pigment Blue 15

Also sold under a variety of exotic titles and names. An extremely powerful, vibrant, deep greenish-blue that must be used cautiously due to its high strength. Lightfast, inexpensive and very transparent.

Phthalocyanine Green

Pigment Green 7 or Pigment Green 36

Varies in colour from a yellowish-green through to a bluish-green. Phthalocyanine Green closely resembles Viridian and, if anything, is even more intense.

A clean, powerful, transparent hue that tends to dominate other colours if used carelessly. Also sold under a variety of exotic and trade names.

Aureolin or Cobalt Yellow

Pigment Yellow 40

Sold under both names, Aureolin is a very bright, transparent colour which, applied thinly, approaches a pure yellow. While prized for its transparency this colour does possess a fair degree of covering power and a quite strong tinting strength. Aureolin takes on a very dull appearance if it is applied heavily as a body colour.

Carefully manufactured, it is relatively lightfast (xxx) but some manufacturers give their product a lower lightfastness rating (xx) so choose carefully.

There is an extensive choice of transparent colours on the market which vary in permanency and value for money. Be very careful. Check the resistance to light very thoroughly and preferably try to restrict your palette to a range of colours over which you will have full control. The fewer the better in most cases.

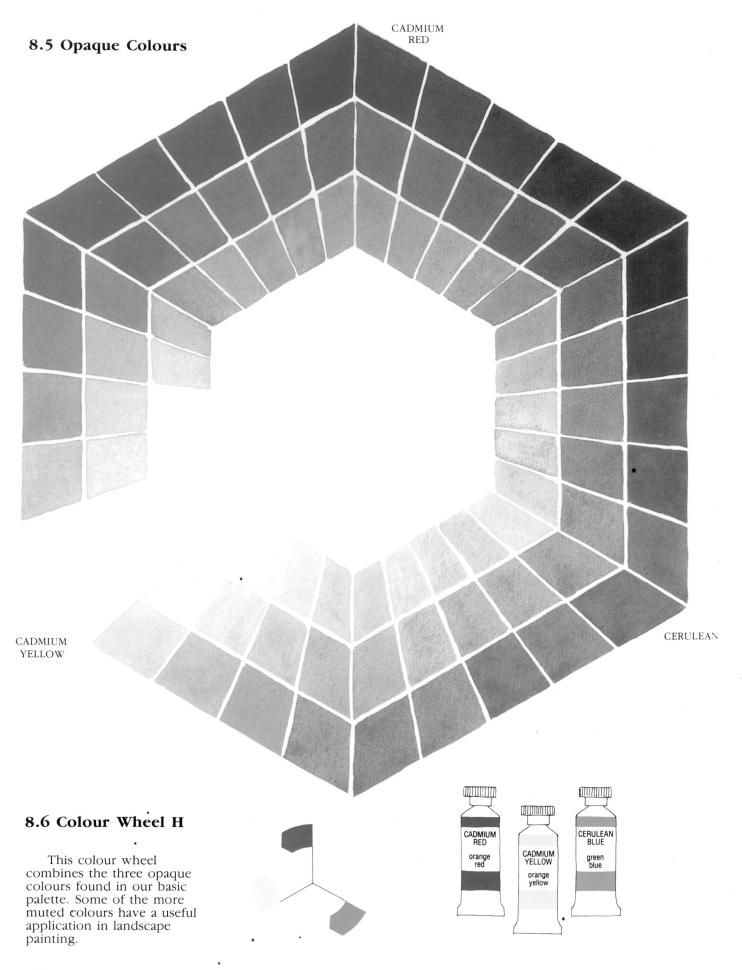

8.7 Further Opaque Colours

Two other opaque colours worth considering are Yellow Ochre and Light Red.

Yellow Ochre

Pigment Yellow 40

A soft, golden yellow that works and mixes well and brings a certain calm to other colours. Good quality makes are fairly transparent in thin layers but Yellow Ochre can generally be considered opaque.

It is extremely reliable because of its lightfastness.

Light Red Oxide

Pigment Red 101

Also called English Red Oxide, English Red and Light Red.

Opaque, with good tinting strength, the colour varies considerably from one manufacturer to another, so check all available brands.

Mixed with white or used as a wash, a range of very attractive, subtle salmon pinks emerge. As with many colours, this undertone or undercolour is often overlooked. Many consider such undertones to be more beautiful than the mass tone or top colour.

Equally reliable alternatives are Mars Red and Indian Red.

Yellow Ochre can bring calm to other colours.

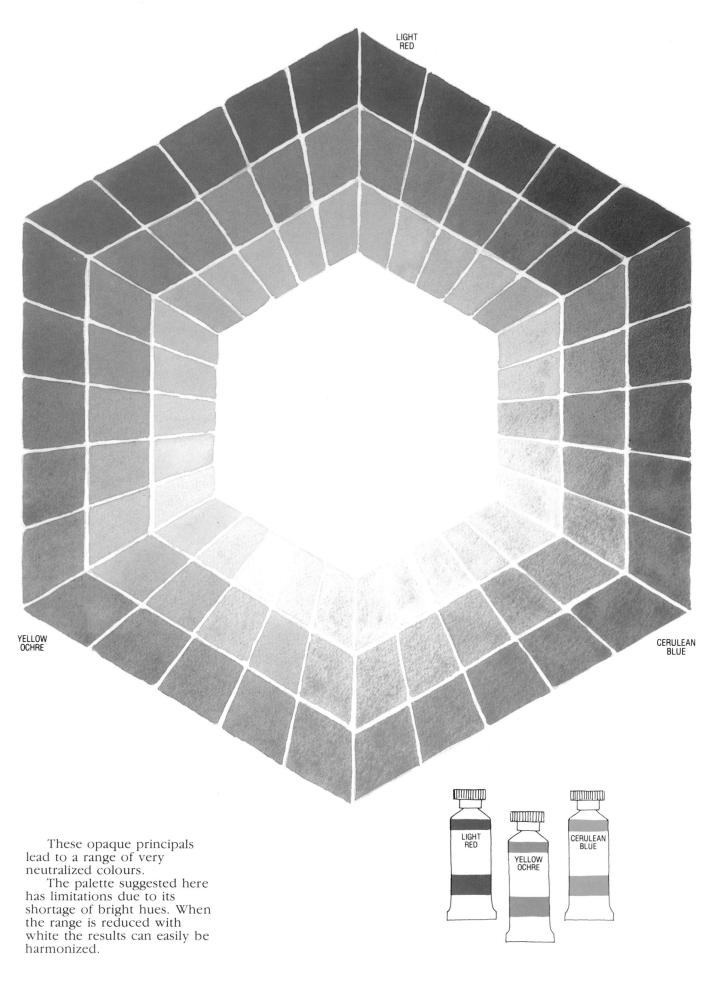

Adding White and Black

Colours are cooled and brilliance is damaged by the addition of white, yet its use is often essential.

The debate over whether or not black should be included in the palette continues, with strong feelings being expressed by both camps.

9.1 Adding White

9.2 Adding Black

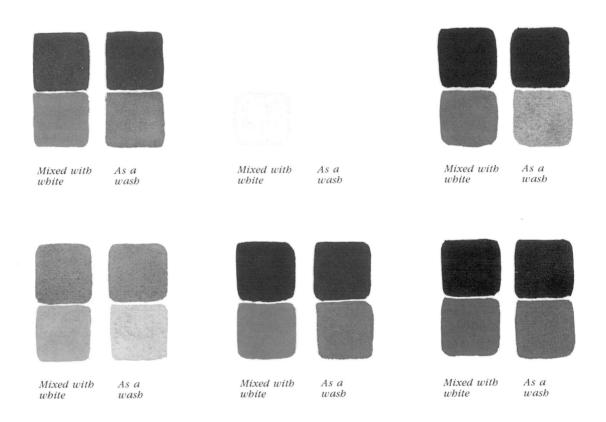

Tints can be produced by either adding white paint or allowing the white painting surface to show through by applying the colour thinly.

Colour brilliance is damaged by adding white paint and this is particularly noticeable in watercolour painting, which relies heavily on clean, transparent tints for much of its effect.

The second method gives the clearest, brightest tints.

Oil and acrylic painters, who usually add white paint to lighten colours, should not overlook the possibility of allowing white underpainting, or white priming, to lighten thinly applied top layers.

In every medium, brilliance is lost and colours are cooled by adding white paint. The warmer colours in particular are cooled by white.

The blues, already cool, suffer less than other colours and retain their character reasonably well.

If need be, steps can sometimes be taken to counteract the cooling effect of the white. A touch of a warm colour can 'boost the temperature'.

An excellent example is violet. When it is reduced to a tint by being applied thinly, violet stays close in temperature and character to the saturated colour.

The same violet however, mixed with white paint, takes on a different character and is dramatically cooled. Just by adding a little Crimson Alizarin to the violet tint, we can counteract the white paint's cooling influence.

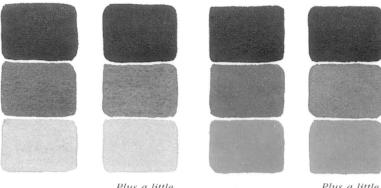

Plus a little Alizarin Crimson.

Plus a little Alizarin Crimson.

As a wash.

Mixed with white.

White paints vary markedly in their characteristics and suitability and should be chosen carefully.

Flake White or White Lead Pigment White 1

In use as a pigment since oil painting began, White Lead has more than proved its worth. Paintings hundreds of years old containing areas in this extraordinary pigment have remained intact while the rest of the work has long since deteriorated.

Due to its chemical reaction with drying oils, Flake White forms an extremely durable and flexible paint film. These qualities, together with its opacity, quick drying capability and buttery texture set it well apart from other pigments.

The drawbacks associated with this white are often exaggerated. True it darkens if exposed to Hydrogen Sulphide in the atmosphere, which makes it unsuitable for use as a watercolour, but made up into an oil paint, it is easily protected by a layer of varnish.

Problems can occur when Flake White is mixed with certain low-grade pigment, especially poorly made Cadmium colours, Vermilion and Cobalt Violet. No such difficulties arise with high quality pigments which the discerning artist will always use. Flake White can usually only be obtained in oil or alkyd paint.

Flake White is a warm and creamy white, qualities that it imparts to mixes.

Titanium White

Pigment White 6

This relatively modern white has removed the concerns associated with combining Flake White and certain poorly produced colours.

Titanium White is a useful covering paint, either alone or in mixes. Its use renders paint films opaque.

This white is absolutely inert, being unaffected by other pigments, light, heat, weak acids or alkaline. Generally considered to be absolutely permanent.

Although an excellent white, it has not replaced Flake White or Zinc Oxide as it has neither the warmth of the former in mixes nor the transparency of the latter. It is not quite as pleasant to use as Flake White since it lacks the buttery texture of that paint. Titanium White is usually only found in oil, acrylic and alkyd paints, although it is also suitable for watercolours.

Titanium White is a lot cooler in mixes than Flake White. It is extremely brilliant and the whitest of the whites.

Zinc White Pigment White 4

A very permanent white that is perfectly safe to use with all other pigments. It is a very pure, cold white. Used in oil paints, it tends to dry to a brittle film which is very prone to cracking. One of the most transparent of the whites. Zinc White is often used

for glazing purposes, either alone or in mixes with other transparent colours. Unless you particularly wish to use a white for glazing, this is a poor buy as an oil paint because the hard, brittle film it forms represents a major defect. Whereas Flake White

has lasted very well on many old paintings, Zinc White has often led to the rapid deterioration of the work.

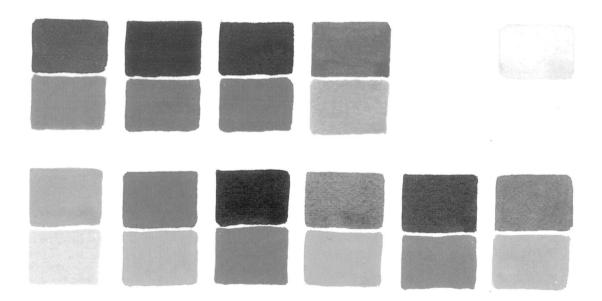

Chinese White

The watercolour Chinese White is a specially prepared, very dense type of Zinc Oxide with a greater covering power than the oil version.

It is the principal white of the watercolourist. Beware of cheaper grades labelled

Chinese White as they are

often ordinary Zinc White. There should be little call for using a white in watercolour painting because the paper itself provides the whites and tints.

The Watercolour painter has little need for white paint, it both cools and dulls other colours.

9.2 Adding Black

A black surface effectively absorbs almost all light striking it due to its molecular makeup. Added to another colour, black pigment absorbs nearly all the light reflected from that other colour.

A black paint absorbs light very efficiently and takes on a darker appearance than a mixed dark.

The debate over whether or not black should be included in the palette continues, with strong feelings expressed by both camps.

Those favouring the use of black argue that black paint must be used to depict extremely dark areas accurately. Another view put forward is that black is a very convenient way to darken a colour.

Let us examine these two arguments:

1. BLACK PAINT MUST BE USED TO DEPICT VERY DARK AREAS.

On the surface this appears plausible.

However, most areas deprived of light are closer to dark grey than black and in fact pure black itself is seldom found in nature.

Many 'blacks' such as say, animal fur, bird feathers and fruits are, on closer inspection, seething with subdued colour. Depicted with black paint they take on a dead appearance.

Trees and other similar objects silhouetted against an evening sky look heavy and unnatural if painted black. The reality is that such darkness is never a true black.

A mixed dark always looks far more natural, containing, as it does, some of the light that will be present on such an evening.

Even the interior of an unlit room in the dead of night does not look entirely black but a deep, shifting, atmospheric dark grey.

If we shut our eyes in total darkness, we do not experience a sensation of total blackness — faint lights seem to wander around in front of our eyes.

There is even a danger in depicting naturally occurring blacks with black paint.

If, for instance, a burnt tree stump is depicted with black, it seldom looks realistic because the effect of distance tends to blur detail and soften the black into a dark grey.

Were the painter to use pure black in depicting this tree, the viewer would be confronted with a black that is too sharp and dense to be realistic.

Perhaps the strongest argument against its use to portray dark areas is that the final result often looks more like a hole in the painting surface than part of the work.

There is a distinct possibility that you will depict damage to your painting rather than portray areas of dark, should you decide to use black unmodified by other colours.

2. BLACK IS A CONVENIENT WAY TO DARKEN A COLOUR.

The addition of black to a hue gives widely varying results:

It moves violet, the darkest of the hues, towards a shade with little damage to its character; blue quickly loses its brilliance; reds are changed in character, although some interesting colours can be obtained; blue-green takes to black rather well, yellow-green less so; and yellow is damaged out of all recognition by even

tiny amounts of black and moves quickly towards a series of greens that many find unwholesome.

There is no such thing as an 'incorrect' colour and indeed some useful results can be obtained by using black. It has to be said, however, that many, including the author, find that black has the effect of 'dirtying' colours to such an extent that its use is seldom if ever considered.

If we combine a colour

with its complementary, or mix red, yellow and blue together, we can readily and accurately depict the darks found in nature.

Black often upsets the balance of otherwise harmonious arrangements. What better way to darken a colour can there be than to add its complementary?

Yet, with all that in mind, the use of black must remain an individual decision.

Lamp Black

Pigment Black 6

Soot given off from the fire was probably the first pigment ever to be used. Lamp Black, produced by burning a wide range of materials, has been in constant use since the cave painter.

Lamp black is a cool, bluish black which varies from transparent to semitransparent. Quite high in tinting strength, with excellent covering power. It is a slow drier in oils.

Raw Umber is often added by the oil painter in order to speed up the drying rate.

When used in water colour and applied in a very wet layer, the pigment is apt to float to the top of the film and separate from other colours. Not usually available as an acrylic.

Value for money if you require a permanent blue-black.

Most black pigments are still produced from carbon obtained by burning various materials such as oils, tars and animal or vegetable matter.

Ivory Black

Pigment Black 9

Originally made by charring ivory scraps in sealed crucibles, it was sold side by side with an inferior black made from charred animal bones, Bone Black.

When the supply of ivory dried up the paint manufacturers found themselves in a quandry. Ivory Black had gained a favourable reputation among painters and it seemed a shame to take it off the market. The answer was to rename the less favourable Bone Black as Ivory Black.

Today Bone Black still remains with us, masquerading as Ivory Black.

It varies from semitransparent to opaque, with reasonably good covering power. The colour of the product has changed over recent years. Normally possessing a warm brown undertone, manufacturers now strive to produce a darker, almost blue black. Prussian Blue is often added in order to darken the colour.

Mars Black

Pigment Black 11

An artificial mineral pigment, Mars Black is a recent addition to the artists' palette. Dense and reliable, the better qualities have been generally welcomed by today's painter.

A deep, warm, brownish black with fairly good tinting strength and very good covering qualities.

In oils it is an average drier, but certainly quicker than Ivory Black.

Suitable for water colour although not generally available.

Being more inert than the carbon blacks, Mars black is especially suitable for acrylic and PVC emulsions.

The better qualities are value for money.

10 Browns

Certain browns are invaluable, but many can easily be mixed from our limited palette.

10.1 How to Make your own Browns

10.2 Manufactured Browns

10.1 How to Make your own Browns

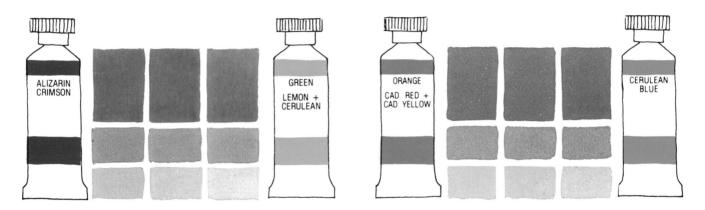

Artists needing a brown invariably reach for a manufactured colour, yet a wide range of browns can very easily be mixed from our limited palette.

Asked to identify their idea of brown, painters invariably select from amongst a range of darkened yellows, oranges and reds.

We now know that the

ideal way to darken such colours is to add a touch of their complementary, for example violet into yellow, blue into orange and green into red.

10.2 Manufactured **Browns**

As you will gather from the exercises, an extensive range of browns can be easily mixed. Most are simply darkened yellows, oranges and reds. You might, however, find the following prepared browns of value.

Raw Umber Pigment Brown 7

Close matches can be mixed but they invariably require the addition of black, which tends to give a less pleasant colour.

Being very transparent. Raw Sienna is an excellent glazing colour — a quality that is seldom made use of. It is possible to obtain a similar colour through mixing, but not one of such transparency.

Raw Sienna has a place on most artists' palettes. It is unsurpassed by modern synthetic products (such as Mars Brown) for beauty, luminosity and permanence.

Other browns can have a place on the palette, but be careful in their selection.

Other Browns

Similar in make-up to Raw Sienna, hence the same Colour Index Number. A particularly pleasant, cool, dark, slightly greenish brown (in the better qualities). Some grades are fairly transparent when applied in thin layers. The products of different manufacturers can vary widely in colour. Lightfast and compatible with other pigments, it is considered a must by many painters.

When mixed with a blue such as Ultramarine it will give rich, deep powerful darks which many consider to be superior to any black paint. The result is so dark because in effect Burnt Umber can be considered a neutral orange and combined with blue we obtain a mix of complementaries.

Raw Sienna Pigment Brown 7

Sepia

Mars Brown can be useful, but is harsher in colour than the natural earth colours.

Van Dyke Brown is a very inferior material which has no place on the conscientious artist's palette.

Sepia is usually a simple mixture of Burnt Umber and a black.

Burnt Umber Pigment Brown 7

A warm, rich, fairly 'heavy' orange-brown prepared by roasting Raw Umber.

Absolutely lightfast and compatible with all other pigments, Raw Sienna lies between Yellow Ochre and Burnt Sienna in colour.

Van Dyke Brown

Mars Brown

11 The Palette

A summary of the paints that we have studied, together with information on mixing 'standard' colours.

11.1 Summary of the Extended Palette

11.2 Mixing "Standard" Colours

11.1 Summary of the Extended Palette

All the colours we have discussed can be usefully grouped under one heading, so that their relative qualities can be considered.

Cadmium Red

Pigment Red 108

Permanence xxx.
Compatible with all well produced pigments. Rather slow drying in oils. Colour varies between manufacturers. Many inferior substitutes on the market. Opaque.

Alizarin Crimson

Pigment Red 83

Permanence normally xxx but fades on exposure if mixed with white or applied as a wash. Compatible with all well produced pigments. Slow drier in oils. Avoid the cheaper grades. Particularly transparent.

Rose Madder Genuine Natural Red 9

Permanence xxx. Highly transparent. Very similar colours are available at less cost. Very weak in mixes which limits its use. Compatible with other pigments.

Quinacridone Reds

Permanence varies, up to xxxx. Wide range available. Exceptionally transparent, brilliant reds. Compatible with all other pigments. Often sold under ridiculous names such as Geranium and Rose.

Light Red Oxide

Pigment Red 101

Permanence xxxx. Compatible with other pigments. Colour varies considerably between manufacturers. Opaque with good tinting strength.

French Ultramarine

Pigment Blue 29

Permanence xxx although quickly bleached by acids such as vinegar and lemon juice. Compatible with other pigments if well made. Very transparent. High tinting strength.

Cerulean Blue

Pigment Blue 35

Permanence xxxx.
Compatible with all other pigments. Student grades (and increasingly artist qualities) masquerading under this name are simple mixes of other, cheaper blues. Genuine article is excellent value. Opaque.

Cobalt Blue

Pigment Blue 28

Permanence xxxx.
Compatible with all other pigments. Subject to adulteration and imitation by mixes containing cheaper blues.
A unique, transparent blue.

Phthalocyanine Blue

Pigment Blue 15

Lemon Yellow

Pigment Yellow 3 (Arylide Yellow)

Permanence xxx. A general name to describe a green yellow. Cadmium Lemon is also reliable — many others turn green. Compatible with other pigments. Transparent.

Cadmium Yellow Pale

Pigment Yellow 35

Permanence xxx to xxxx. The modern product is compatible with all pigments. Opaque but strong enough to be applied in a thin layer for a semi-transparent effect.

Aureolin (Cobalt Yellow)

Pigment Yellow 40

Permanence xxx for good makes. Compatible with all other pigments. A clear delicate colour when applied thinly. Heavy and dull laid on thickly. Particularly useful as a glaze.

Yellow Ochre

Pigment Yellow 43

Permanence xxxx.
Compatible with all pigments.
Quality products can be quite transparent applied thinly but the colour is usually considered to be opaque. A soft, neutral yellow.

Viridian

Pigment Green 18

Permanence xxxx.
Compatible with all pigments.
Use only the better grades.
Highly valued as a glazing
colour due to its transparency.
A very bright, clear, cool
green.

Phthalocyanine Green

Pigment Green 7 or Pigment Green 36

Burnt Sienna

Pigment Brown 7

Permanence xxxx. A brilliant, rich red brown. Compatible with all other pigments. Displays its true beauty when applied thinly. An excellent glazing colour due to its transparency.

Flake White (White Lead)

Pigment White 1

Permanence xxx. Usually only available in oils or alkyds. Compatible with all other well produced pigments. A warm, creamy white that dries to a tough flexible film. Quick drying. Opaque.

Titanium White

Pigment White 6

Permanence xxxx.

Absolutely inert, unaffected by other pigments, light, heat, weak acids or alkaline. Cooler in mixes than Flake White.

The whitest of the whites.

Zinc White

Pigment White 4

Permanence xxxx. A very pure, cold white. Compatible with all other pigments. In oils dries to a hard, brittle film prone to cracking. Mainly used for glazing due to its transparency.

Chinese White

Pigment White 4

Permanence xxxx. The principal white of the water colourist. Very dense, with greater covering power than the oil version. Compatible with all other pigments. Opaque.

Ivory Black

Pigment Black 9

Permanence xxxx. Colour varies from a warm brown black (applied thinly) to a dark blue black. Can be used in all techniques. Compatible with other pigments. Semitransparent to opaque.

Mars Black

Pigment Black 11

Permanence xxxx. An excellent dense black. Varies in colour, usually a deep, warm brownish black if applied thinly. Good covering power and high in tinting strength. Fully compatible. Opaque.

Lamp Black

Pigment Black 6

Permanence xxxx. A cool bluish black. Quite high in tinting strength with excellent covering power. Compatible with other pigments. Slow drier in oils. Transparent.

Raw Umber

Pigment Brown 7

Permanence xxxx. A pleasant, cool, slightly greenish dark brown. Colour varies. Student and artist qualities equally permanent. Compatible with other pigments. Some grades fairly transparent.

Burnt Umber

Pigment Brown 7

Permanence xxxx. Compatible with all other pigments. A warm, rich, rather heavy reddish-brown. Valued for its versatility, it is considered essential by many painters. Suitable for all media.

Raw Sienna

Pigment Brown 7

Permanence xxxx. As with many other browns it is equally reliable in both student and artist qualities. Compatible with other pigments. Very transparent, it makes an excellent glazing colour.

11.2 Mixing "Standard" Colours

Many of the colours offered by paint manufacturers are simple mixes easily duplicated on the palette. Although some of them have a place as convenience colours, many are composed of materials which are unsuitable for artistic use.

If you work through the exercises as suggested, you will find that even with a limited palette you will be able to duplicate many of the colours that you might otherwise have purchased.

Some of the more common examples of pre-mixed colours are as follows:

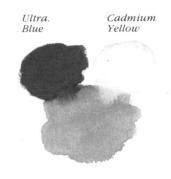

Shown here is a typical 'Sap Green', this time mixed from reliable pigments. You will find many such greens in the colour mixing exercises.

Sap Green

A variety of Sap Greens are available, invariably made up of poor materials.

Originally made from ripened berries it is now produced from almost any concoction of blue and yellow. The materials used are invariably of poor quality, giving a very inferior paint, prone to fading or changing in some other way. It is possible, but not easy, to find a reasonably lightfast product.

The various dull greens sold under this label are easily duplicated on the palette.

Naples Yellow

Naples yellow is a convenience colour which is very easily mixed.

Genuine Naples Yellow is a lead-based pigment with some excellent properties. Drawbacks in its use (it is not suitable for water colour, pastel etc.) and difficulties in production have brought about the widespread manufacture of substitutes which are usually no more than mixes of yellows and whites.

A variety of Naples Yellows are available, all simple mixes.

In oils it is generally a mix of Cadmium Yellow and Flake White with small additions of Yellow Ochre and/or Light Red to achieve the different values that are offered.

As a water colour it is usually a mixture of Cadmium Yellow, Chinese White and Yellow Ochre. A useful convenience colour which is easily produced on the palette.

A popular, opaque bluegrey which has a soft, darkening effect on other colours. Usually produced from a combination of Ultramarine and a black. An ochre is often added to soften the colour. Another convenience paint that can easily be duplicated on the palette.

It is a colour that has to be handled carefully as it can quickly dominate and unbalance a painting.

Hookers Green

Hookers Green has become a 'dumping ground' for inferior yellows and blues.

Originally an inferior water colour paint produced from a simple mix of Prussian Blue and Gamboge. Nowadays it is still usually an inferior or at least an unnecessary premixed paint available in a variety of mediums. The ingredients have changed to include almost any blue and yellow. Having checked the contributing colours used, I

have come to the conclusion that the only limit is the imagination of the blender and the range of base colours available.

Hookers Green has become a dumping ground for cheap and inferior pigments.
Occasionally, and almost by default, manufacturers do use better quality pigments. Any of the proprietary greens offered under this label are easily mixed.

Emerald Green

A highly poisonous substance no longer available, Genuine Emerald Green cannot be matched exactly by mixing, but a close likeness can be achieved by combining Phthalocyanine Green with Lemon Yellow. Why buy it ready mixed when you can make it yourself? The same easily prepared colour is also sold under such names as Permanent Light Green. A little white paint is sometimes added to give variation.

Sepia

Mix a little Lamp Black with Burnt Sienna and you have the same concoction as the one sold under this name.

Many other manufactured colours could be added to this list. Once you gain control over the limited palette suggested and become familiar with the other colours described, you will be able to work with far fewer colours than is the norm and be sure of their qualities. If you are ever tempted to add further colours to your range, be sure that you could not just as easily mix them.

12 Mixing Various Media

The laws of subtractive mixing apply to all colour blending that does not involve either coloured lights or optical mixing.

- 12.1 Pastels
- 12.2 Coloured Pencils
- 12.3 Silk Screen Inks
- 12.4 Watercolour
- 12.5 Gouache
- 12.6 Oil Paints
- 12.7 Acrylics
- 12.8 Placing Further Colours
- 12.9 Subtractive Mixing in Practice

12.1 Pastels

The laws of subtractive mixing apply to the use of all types of liquid paint, all inks, soft and hard pastels, oil pastels, wax crayons and coloured pencils. In fact they apply to any mixing that does not involve either coloured

lights or optical blending.

Once the basic rules are understood they can be used for any suitable medium. They are not difficult guidelines to follow and their application can quickly become second nature.

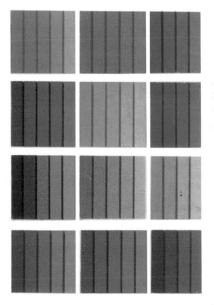

Pastel colours are not easy to combine.

Pastels are available in a very wide variety of colours, the selection of which can be extremely bewildering. The frequent use of some particularly fanciful names does not help the situation.

Neither does the fact that the ingredients and resistance to light are seldom indicated.

Hatching, or crosshatching, together with further blending by finger or torchon are the only means of mixing the

colours. Such a rather awkward process makes the mixing of pastels somewhat less efficient than the mixing of liquid paints. This has led to the wide range of premixed colours.

The Colour Bias Wheel can be employed as an aid in all forms of subtractive mixing.

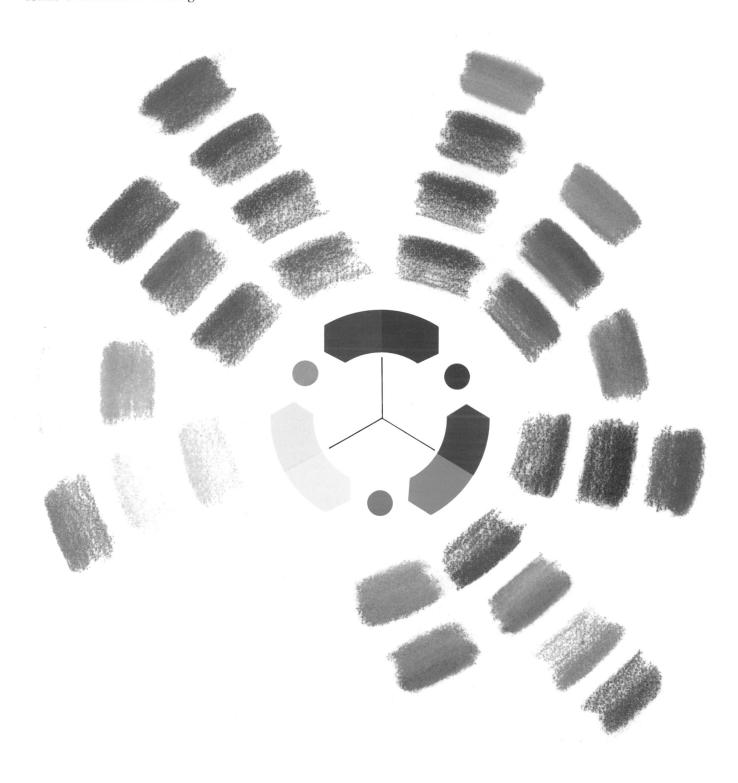

Before trying out any of the mixing exercises you should decide on the 'types' of colour that you have in your palette. Reds should be sorted out into the orange-reds and the violet-reds, blues into violet-blues and green-blues and yellows into green-yellows and orange-yellows.

Many pastels have vague, meaningless names.

If you are unsure of a particular colour's bias, you can soon identify it with a few sample mixes. Let's say that you have a red that is difficult to place. The name does not give a clue as to the type of red that it is and it does not appear to lean strongly in

The bias of the red will be revealed if it is mixed with a known blue.

either direction. The first thing to do is to mix it with a blue that is obviously biased towards violet. Mix the red with Ultramarine; if the result is a rather drab grey-violet you can be sure that the red is biased towards orange; if the mix is a clear violet the red

This test will prevent any confusion between colour 'types'.

leans towards that colour and can be placed accordingly.

Other colours can be similarly arranged into 'types'.

By setting out sample colours from your palette, as shown opposite, you can always be sure of the colours to select for any given result.

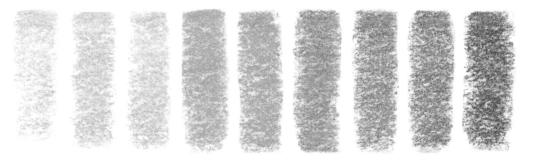

The same rules of subtractive mixing apply with pastels as they do with liquid paints.

The exercises outlined in the book should be followed, using pastels, if you are to gain total control of your palette.

Although thin applications have a certain transparency, pastels can only really be considered opaque or semi-opaque.

The usual practice is to mix pastels from dark to light.

12.2 Coloured Pencils

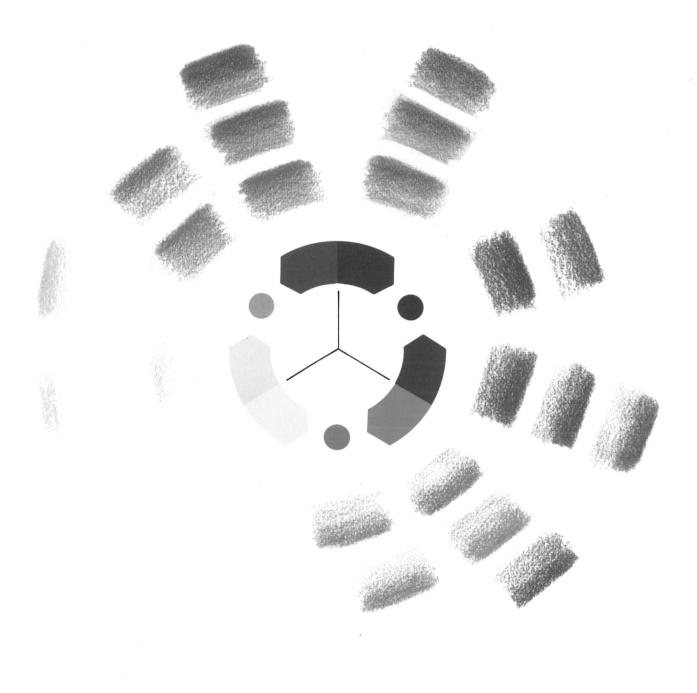

Like pastels, coloured pencils present difficulties when it comes to combining colours. Hatching, or crosshatching must be employed. Nevertheless, a good range of delicate, subtle

results can be obtained from just a few colours.

Coloured pencils are even more vaguely labelled than pastels — if they are given a colour name at all.

Once again, it would be of

great benefit to arrange your selection according to each colour's bias. As with the pastels, a few trial mixes will enable you to classify colours according to 'type'.

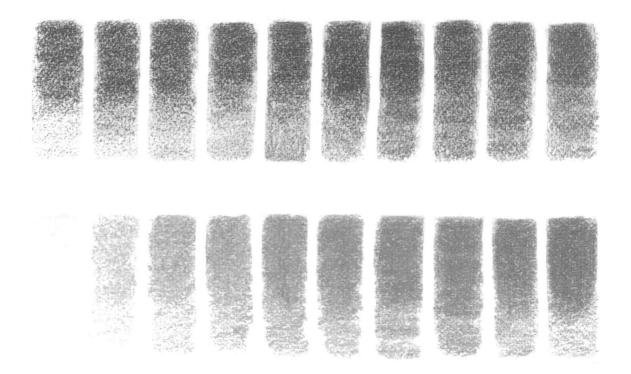

When you have decided on each colour's bias, you will learn a great deal by working through the exercises in the book.

Regardless of the medium, complementaries can be relied on to neutralise each other, thanks to the laws of subtractive mixing.

12.3 Silk Screen Inks

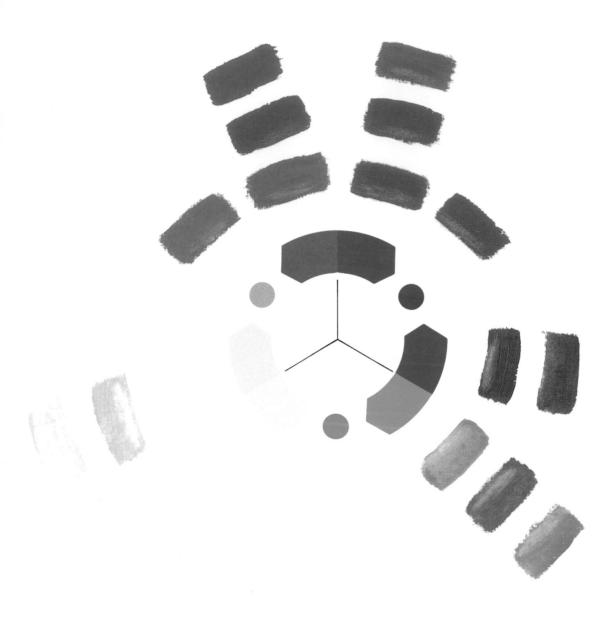

Nomenclature of silk screen materials, others use exotic, inks varies considerably between manufacturers. Some name their colours to correspond with the more familiar titles of the painter's

meaningless names.

Rather than try to make sense of the labels, spend your time arranging the colours according to their biases. The

yellows and blues are usually quite easy to place by sight alone. If in doubt, try a little experimenting.

The yellow that combines with a greenish blue to give a dull green obviously leans towards orange and should be placed accordingly.

If a bright green results, place the yellow in the 'Lemon Yellow' position on the wheel.

Reds are often the most difficult to judge by sight. If the container is labelled say, Magic Red Number 3 and you cannot confidently decide on its leaning, mix a little with a known violet-blue. If a greyed violet results then you know that Magic Red Number 3 is similar in character to a Cadmium Red. It is biased towards orange. If a bright violet results then you have a red leaning towards that hue on your hands.

Whether oil or water-based, most screen inks are opaque when they are applied heavily.

Either by thinning or through adding a special base, the inks can be made transparent.

Overprinting with transparent inks produces further colours.

The rules of subtractive mixing are applicable whether the colours are physically mixed or applied as glazes.

Complementaries will still darken each other and produce greys when they are evenly combined.

A knowledge of the six colour 'types' is essential. An orange yellow and a violet blue make a dull green in screen inks no matter how they are combined.

12.4 Watercolour

Fortunately, the nomenclature of watercolours is uniform between manufacturers. Although some rather meaningless names are still widely used, they are reserved for the less important colours.

If you have colours other than those so far examined, their bias should be ascertained first before they are used.

One of the great beauties of watercolour painting is the ease with which different techniques can be combined. Wet into wet, wet on dry, glazing etc. In order to take advantage of this flexibility the painter must have full control over colour mixing and a clear understanding of the characteristics of each colour. The differences in transparency in particular should be noted.

Note:

As all of the exercises in the book were carried out using watercolours, the bias of the major colours should be well established.

Staining Colours

Certain pigments possess phenomenal strength and must be used with caution. These are the staining colours, they will stain both the paper and other pigments.

Once applied they are impossible to remove and difficult to alter. Although they can be used to provide deep but thin darks, their ability to stain other colours can be a distinct disadvantage.

Colours such as Phthalocyanine Blue and Green fall into this category.

Staining Test

Apply a small patch of each colour to be tested onto the

same type of paper as you normally use.

After the paint has dried, soften it with a clean wet brush.

Remove the paint by either running the paper under a tap or by washing it with a very wet sponge.

Once the paper has dried it is easy to identify the staining colours.

12.5 Gouache

Gouache, also known as 'Designers Colour', is simply opaque watercolour. Standard watercolours are made opaque by the addition of either white paint or an inert pigment such as precipitated chalk.

Available in tubes, jars, pans and cakes, gouache is used extensively by commercial artists since its opacity makes it very suitable

for reproduction.

The smooth texture and opacity of gouache is attracting an increasing number of painters working in the field of fine art, painters who all too often do not realise the limitations of this medium.

Manufactured primarily for the graphic artist, the gouache range includes many bright but fugitive colours. The work of the commercial artist is, for the most part, kept away from light in a folder and is not usually intended for an especially long life.

If you choose to work in gouache, pay attention to the manufacturer's literature and select only the lightfast colours.

Although many are lightfast, some gouache paints can fade so much that only a

trace of colour remains, even after a short exposure.

12.6 Oil Paints

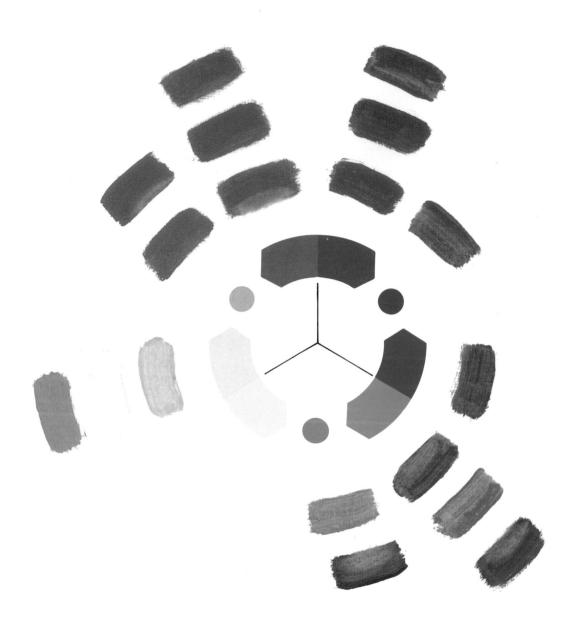

Once the bias of a colour has been established, whether by sight or by experimenting, position it around the bias wheel.

5

As with any medium, the bias of an oil colour can be confirmed quickly by a simple test. If you are unsure of a yellow, for example, mix it with a known orange red such as Cadmium Red.

If the result is a bright orange then the yellow is biased towards orange. If the mix is a rather drab colour then the yellow is obviously biased towards green and should be used as such.

Some yellows however are rather weak and easily swamped by the red. Should this be the case, the bias may be more difficult to establish.

As a further test mix the yellow with a green blue such as Cerulean Blue.

If the resulting green is dull it follows that the yellow is biased towards orange.

If it is bright then the yellow must lean towards green.

Slow drying oil paints lend themselves to the technique of painting wet into wet, the colours being mixed on the painting surface rather than on the palette.

This method of mixing can produce very fresh, sparkling results due to the partial blending of the paints.

Without a clear understanding of colour mixing this approach is invariably disastrous. Instead of fresh, spontaneous results, the work looks very muddy. An intended bright violet, for example, is destroyed by the use of an orange red, or through the inclusion of a little yellow paint. Likewise a fresh green can turn dark should Ultramarine or a tiny amount of red be added.

When you understand colour mixing, the technique

of mixing directly on the canvas will be at your disposal.

12.7 Acrylics

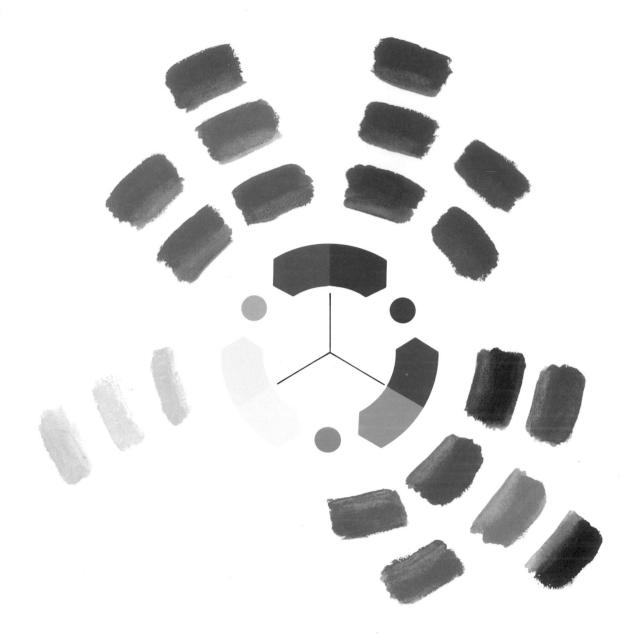

Many of the traditional pigments used in oil and watercolour paints are also available in acrylics, a medium recently introduced. To these have been added an extensive range of modern synthetic colours of great strength and

brilliance. Many of these relatively new colours are particularly transparent, making them ideal glazing colours. Shown here is a typical range of acrylic colours.

The speed with which acrylic paints dry can be an advantage in some respects though it makes colour blending very difficult and virtually rules out the technique of mixing directly on the painting surface.

In order to slow the drying rate, a retarding medium can be added to the paint. Colour blending becomes possible but

overuse of the retarder makes the paint more transparent, a quality not always wanted.

To reduce this tendency towards transparency and to make colour mixing on the surface possible, the retarder medium can be applied directly to the area to be painted and the colours worked into it.

Where transparency is required, a gel medium can be added to the paint. The drawback, however, is some loss of intensity (red moves towards pink for example).

Because the binder and additives are all slightly turbid, acrylic glazes can never equal an oil glaze in either transparency or depth of colour. Neither can they match the clarity of a watercolour

Acrylics darken slightly as they dry but with experience you can allow for this.

12.8 Placing Further Colours

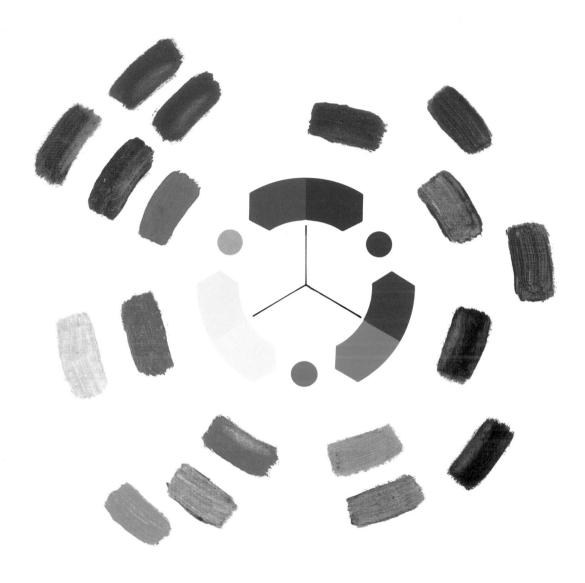

The bias wheel accommodates any colour except black and white and once you are familiar with its use and can place any red, yellow or blue according to its bias, any additional colours you may wish to use can also be positioned.

Manufactured greens, oranges and violets can be The differences between blue violets and red violets, for example, are usually obvious. If in doubt the colour can be placed in the centre, halfway between the red and blue positions.

The duller hues such as Naples Yellow and Light Red are a little more difficult to decide upon. An exact categorised quite easily by eye. positioning is less important in their case as such colours have a relatively minor role to play.

Shown here are just some of the colours that can usually be found in an oil painter's box. This is not to suggest they are necessarily useful, suitable or could not easily be mixed. Such decisions will be yours to make.

4

Once you have categorised the colours you intend to use, the decisions about how to use them follow easily.

For example, Yellow Ochre can now be considered a neutralized orange yellow rather than as a nondescript yellowish brown.

Mixed with Cadmium Red it produces a soft, neutral, opaque orange.

With Cerulean Blue a gentle, dull, opaque green emerges.

5

Moving across the wheel, Yellow Ochre can be used to neutralise (and at the same time make less transparent) a violet mixed from Alizarin Crimson and Ultramarine Blue.

If Burnt Sienna is treated as a transparent red orange rather than a type of brown, it will become a much more versatile colour.

It can be used to darken a transparent blue such as Ultramarine.

7

9

Or glazed over Lemon Yellow to provide a slightly neutral transparent orange.

An opaque mid-green such as Oxide of Chromium can be moved towards blue with Cerulean Blue or moved

towards blue and dulled at the same time with Ultramarine Blue.

12.9 Subtractive Mixing in Practice

The aim of this book has been to provide information which will enable the reader to turn colour mixing from a haphazard affair, shrouded in myth, into a thinking process.

Once the basic rules of subtractive mixing are fully understood, their application, after a little practice, will quickly become second nature. We can reduce these rules to the following:

1. In mixing bright, clear violets, oranges or greens, select contributing colours that both carry the same bias as the one you require. For example, if both the yellow and the blue are biased towards green, they will mix into a pure green.

4. Greys can evenly mixing complementa red and green complementation of the properties of the

- 2. In order to produce a dull or neutralized violet, orange or green, select contributing colours that are inefficient 'carriers' of that colour. For instance, using a blue that leans towards violet dulls an otherwise bright green. The colour can be further dulled by introducing a yellow biased towards orange.
- 3. To neutralize any colour, add its complementary (red to green for example).
- 4. Greys can be produced by evenly mixing a complementary pair, such as red and green.

Colour mixing should be a thinking process based on knowledge.

By understanding the processes that take place within the paint film, a colour can quickly be taken in any direction you choose.

As an example, let's take a red with a bias towards orange, such as the painter's Cadmium Red.

It can be moved towards bright orange by adding an 'orange'-yellow.

Made into a dull orange with a 'greenish'-yellow.

Slightly darkened and softened with a red biased towards violet.

Moved towards a dull violet with a 'violet'-blue.

Towards an even duller violet with a blue biased towards green.

Neutralised with a green.

With a little thought and practice, any colour can be manipulated in this fashion.

Let others buy, use and waste needless colours. Spend more time mixing than applying colours and then be obliged to work with a very restricted range.

Taken towards grey with green.

Turned into a 'dusky' pink by adding white to create a tint and green to dull that colour. And on it goes.

You now have the information to gain total control over your palette. Your work can only improve.

Appendix A

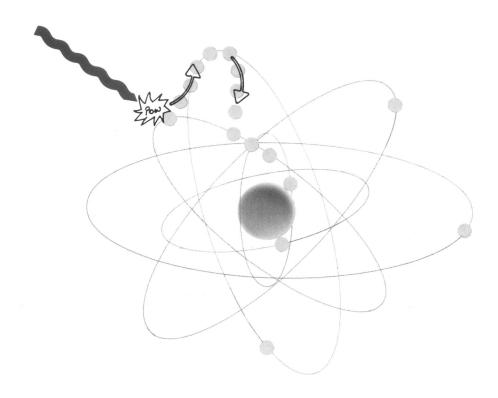

Light Absorption

We have already established that a surface reflecting all wavelengths equally appears white and a surface absorbing all wavelengths appears black. More selective surfaces absorb or reflect only some wavelengths. They appear the colour of the reflected portion of the light.

Absorption of light takes place when the energy within the light is compatible with

the energy within a surface.

All matter is made up of atoms seething with energy. Electrons constantly orbit the nucleus of the atom in much the same way that planets orbit the sun.

Light consists of wavelengths of differing energies. In this illustration the energy of the red portion of the light has just enough power to push one of the electrons into a different orbit.

The electron stays in its new orbit momentarily and then returns.

The effort of moving the electron converts the radiant energy of the light into heat energy. If other atoms in the same surface were compatible with the energies of yellow, orange, green and blue light, the surface would appear violet, that being the only colour able to survive intact.

Appendix B

A tiny amount of light escapes from the surface of any mix and combines additively.

The escaping light joins and influences the coloured light leaving the paint film. In this example the blue and

yellow lights mix additively to make white, this white then slightly lightens the green from within the film.

Subtractive Mixing?

True subtractive mixing takes place when light is absorbed or reflected by the pigment particles. At the surface of the paint layer a certain amount of colour is reflected immediately that does not fall foul of another, differently coloured pigment. These escaping colours

combine with each other ADDITIVELY. They are, after all, coloured LIGHTS and will combine as such.

When paints are mixed therefore, the result is a combination of ADDITIVE and SUBTRACTIVE mixing. The exact relationship between these two mixing processes

varies with the type of pigment and its transparency.

The precise relationship is best left to the scientist to determine. As far as the artist is concerned, paints mix in a predominantly SUBTRACTIVE way and follow, for the most part, predictable rules.

Appendix D

Information about the blue can be plotted on a graph.
The spectral curve will show how the colour is built up.

In order to make the graph easier to read the colours can be added. As you will see, the diagram is now much the same as the bar charts used in the book.

Spectral Curves

A spectrograph is a device able to split light into its component wavelengths and to measure and record the information. The type and amount of light is registered either photographically or on a graph.

When recorded on a graph, the line that is plotted is known as a spectral curve.

The spectral curve shows at a glance the range of wavelengths being reflected by a particular colour. It also shows the percentage of light involved.

Note:

The limitations of conventional printing make it impossible to depict certain colours accurately. Yelloworanges, oranges and redoranges in particular appear rather dull. The introduction of further colours to remedy this situation would have made the book prohibitively expensive.

As I have indicated elsewhere, the illustrations are intended as a guide only and you will gain a great deal by actually mixing the colours in your own chosen medium.